# A BRUSH
# WITH ART

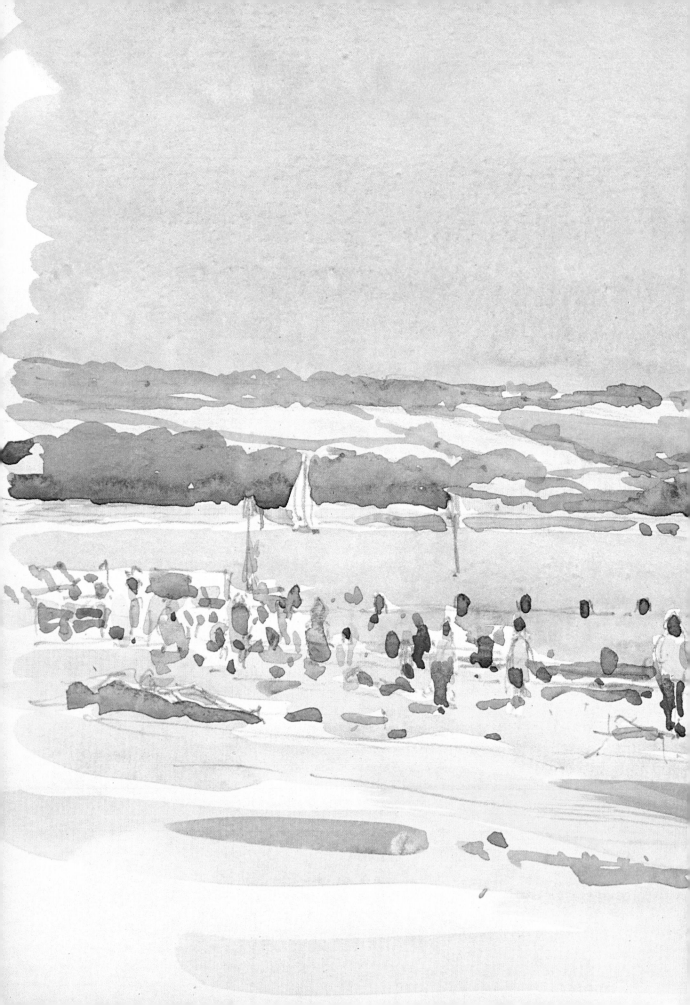

# A BRUSH WITH ART

## ALWYN CRAWSHAW

**North Light Books**
Cincinnati, Ohio

First published in U.S.A. in 1993 by
North Light Books, an imprint of
F&W Publications, 1507 Dana Avenue,
Cincinnati, OH 45207 (1–800–289–0963)

First published in the UK in 1991 by
HarperCollins Publishers
London

Consultant Editor: Flicka Lister

Designed and typeset by
Brown Packaging Ltd
255-257 Liverpool Road
London N1 1LX

Photography: Nigel Cheffers-Heard
Location photographs: David John Hare and
June Crawshaw

**A catalogue record for this book is available
from the British Library.**

**Jacket illustrations:** *Brixham Harbour* (front); *Dawlish
Warren Beach* and *Hay Tor* (back); photograph of the
author by Nigel Cheffers-Heard
**Title page:** *Dawlish Warren Beach* (actual size 21 x 29
cm/8¼ x 11½ in)

ISBN 0–89134–536–1

Printed and bound in the UK

ACKNOWLEDGEMENTS

I would like to record my grateful thanks to all the
team who worked on the TV series – in particular
David John Hare, the producer, and Ingrid Duffell,
the director, and, of course, TSW for their
tremendous support.

I would also like to express my sincere thanks to
Cathy Gosling from HarperCollins, and to Flicka
Lister for the editing of this book. Finally, to June,
my wife, for all the help she has unselfishly given
to both the book and the filming of the TV series.

# CONTENTS

# FOREWORD

When somebody told me that there were seven million leisure painters in the UK, it seemed odd to me that there had been no recent television programmes about painting. After all, there are endless programmes about other hobbies, such as cookery, gardening and fishing. I soon discovered the reason - the broadcasters I contacted simply didn't believe that an audience existed.

Determined to prove them wrong, I decided to produce a series for leisure painters myself and started to look for an artist with the right personality to present a television programme. Then I met Alwyn Crawshaw, and knew I needed to look no further. An excellent communicator, and experienced at teaching amateur painters, Alwyn would also appeal to people who might never pick up a paintbrush but who would still thoroughly enjoy watching over an artist's shoulder while he worked.

In addition to making the series appeal to the widest possible audience, I wanted to shoot the programme entirely on location. Up until now, with rare exceptions, learn-to-paint programmes have been confined to television studios, where the light is always constant, it never rains, and where passers-by don't walk in front of the camera! But, as most leisure painters paint outside, we decided that this series should also be filmed outside so that, if rain or something else ruined our plans, it was all part of the painting experience. After all, it would be hard to believe Alwyn when he says, "Have a go, it's easier than you think", if he was perched on a comfortable chair in an air-conditioned studio!

I then wrote to Television South West, the ITV company serving the region in which Alwyn lives. Our luck was in. They responded immediately and decisively, saying that they wanted 12 programmes – a large number considering that I hadn't worked for them previously and that Alwyn hadn't presented a TV programme before.

It was both refreshing and nerve-wracking to be working for a broadcaster prepared to put such faith in the unknown, and I would like to thank Paul Stewart Laing, Director of Programmes at TSW, and Thomas Goodison, Commissioning Editor for Education, for having that faith. I would also like to thank Ingrid Duffell, the director, Bob Edwards, the cameraman, Graham Pearson, the sound recordist, and Dave Elliott, the editor, for making the series such a success.

Originally intended to be a local series for regional television, *A Brush with Art* is now on national television, released on video and is accompanied by this book. Two further television series with Alwyn have been made and, to date, *A Brush with Art* has also been shown in Ireland, Turkey, Italy and Singapore.

I hope that the television series and this book will bring Alwyn Crawshaw to an even wider audience, and perhaps inspire even more people to take up painting in watercolour.

David John Hare
Producer, *A Brush with Art*
London, July 1991

# PORTRAIT OF THE ARTIST

Successful painter, author and teacher Alwyn Crawshaw was born at Mirfield, Yorkshire, and studied at Hastings School of Art. He now lives in Dawlish, Devon, with his wife June, where they have opened their own gallery. As well as painting in watercolour, Alwyn also works in oils, acrylics and pastels. He is a Fellow of the Royal Society of Arts and a member of the society of Equestrian Artists and the British Watercolour Society.

Alwyn's previous books for HarperCollins include eight in their *Learn to Paint* series, *The Artist at Work* (an autobiography of his painting career), *Sketching with Alwyn Crawshaw*, *The Half-Hour Painter* and *Alwyn Crawshaw's Watercolour Painting Course*.

In addition to this 12-part Channel 4 television series, *A Brush with Art*, Alwyn has made two further television series – one on working with oils and another entitled *Crawshaw Paints on Holiday* – all commissioned by TSW – Television South West.

Alwyn has been a guest on local and national radio programmes, including *The Gay Byrne Radio Show* in Eire, and has appeared on various television programmes, including BBC Television's

*Pebble Mill at One*, *Daytime Live* and *Spotlight South West*. Alwyn has made several successful videos on painting and is a regular contributor to *Leisure Painter* magazine. Alwyn organises his own painting courses and holidays as well as giving demonstrations and lectures to art groups and societies throughout Britain.

Fine art prints of Alwyn's well-known paintings are in demand worldwide. His paintings are sold in British and overseas galleries and can be found in private collections throughout the world. Alwyn has exhibited at the Royal Society of British Artists in London, and he won the prize for the best watercolour on show at the Society of Equestrian Artists' 1986 Annual Exhibition.

Heavy working horses and elm trees are frequently featured in Alwyn's paintings and may be considered the artist's trademark. Painted mainly from nature and still life, Alwyn's work has been favourably reviewed by critics. *The Telegraph Weekend Magazine* reported him to be 'a landscape painter of considerable expertise' and *The Artist's and Illustrator's Magazine* described him as 'outspoken about the importance of maintaining traditional values in the teaching of art'.

# INTRODUCTION

There are many people who would like to paint but don't know how or where to start. Both with this book and with the television series *A Brush with Art*, I have set out to remove some of the mystique that surrounds watercolour painting, and to give you the inspiration to simply get started and have a go. You may be another John Constable but, until you try, you'll never know!

If you are a beginner, remember that becoming a proficient artist doesn't happen overnight. However, with practice, it can happen far more quickly than you think. You will find that, as you progress, your own individual painting style will start to emerge. Everyone is different and no one artist's work is the same as another's. One subject could be painted by 20 different artists at the same time and all the resulting paintings would look quite different. That is one of the things that makes painting so interesting.

Whatever you do, relax and enjoy your painting. Start by coming with me to some of my favourite places in this book – look over my shoulder and share my thoughts as I paint. I'm going to show you how to paint water, skies, boats, all sorts of things – and it's not as difficult as you think!

*Alwyn Crawshaw*

9

whole pan          half pan

# MATERIALS

All artists have their favourite colours, brushes and other materials. There is plenty of choice and, as you gain experience, you will enjoy going on to make your own decisions about which ones to use, and discovering for yourself what suits your style of painting best. But to start with – while you are learning – make your keyword simplicity. By starting simply, you will not only make things much easier for yourself, you'll also find you get the best results.

When following the television series and working through this book, I suggest you use the materials I use. And do remember, in order to get the best results from your painting, you should use the best quality materials you can afford.

## COLOURS

There are two types of watercolour paint and they differ in both quality and cost. The best quality are called Artists' quality Watercolours, and those a grade lower are called students' watercolours, some of which are manufactured under brand names such as Daler-Rowney's Georgian Watercolours. I always use Artists' quality – they really do make all the difference because you get stronger colours and they are much easier to mix than students' watercolours.

Watercolour paints can be bought in a ready-fitted box, or you can buy a box separately and fill it with the colours of your choice. The watercolour pans which hold the paint come in two sizes: a whole pan and a half pan. Throughout this series, you'll see I've kept to a paintbox containing just six half pans of colour, except for the studio painting on pages 58-59 and *Brixham Harbour* on pages 78-79.

Watercolour paints can also be bought in tubes; you squeeze the paint on to your watercolour palette or the open lid of your paintbox and then use it in the same way as pans. However, I don't advise beginners to use tubes – in fact, I rarely use them myself. It's far easier to control the amount of paint on your brush when you are using pans.

*My large paintbox (which I use for studio work and large paintings outside) holds 12 whole pans but I normally only use six colours. I use this size box because of the large mixing areas*

## BASIC KIT

Apart from your paintbox, what other materials do you need before you can start watercolour painting? If you go into any art shop, you'll see that the list of tools you *could* acquire is almost endless! Don't worry – it's easy to cut through the confusion and get down to basics. Please note, though, that by 'basics' I'm referring to the minimum quantity of materials you need to get you started – and never to the quality of the ones that you should choose.

Brushes are very important but you don't need many. Just three will be quite sufficient: a No. 10 and a No. 6 round sable, and a Dalon Rigger Series D.99 No. 2 (a very thin one). These are all I've used in the series.

You will also need an HB pencil and a 2B pencil for sketching, a putty eraser, a water-carrier, and something to hold your water in while painting. Last but not least, you'll need paper on a drawing board or pad. Depending on your sketch pad size, you might be able to put the whole lot in your pocket or handbag, particularly if you take

my advice and keep your materials simple to begin with. I don't use an easel, as it is usually easy to work with the board, or pad, on my knees.

The top picture shows me in my painting waistcoat, which I often wear for outside work. This is shower-proof and has pockets large enough to carry all the materials I need as a professional, plus extras like a knife for sharpening pencils, a small sponge, blotting paper, spare rubber bands to hold the sketchbook pages down, a box of sticking plasters and aspirin – when out painting I always carry these things, just in case!

For most of my small outdoor work, up to 28 x 41 cm (11 x 16 in), I use the Travelling Studio, which I designed myself and which is now on the market. I use this in nearly all the programmes. This solves the age-old problems of finding somewhere to put my water jar and keeping all my equipment neatly at hand. The shoulder strap can also be worn round my neck to support the kit, the water cup is held firmly on the tray, next to the paintbox, and my left hand supports the pad. You can even stand up and paint with this kit – I never go anywhere without it.

The contents of the Travelling Studio are: six Daler-Rowney Artists' quality Watercolours (my colours) in a removable aluminium paintbox, a sable brush, a spiral-bound Bockingford Watercolour Paper pad, 13 x 18 cm (5 x 7 in), and a pencil. It also contains a rustproof water bottle and water-cup holder. All this is neatly held together in a tough PVC waterproof case with carrying strap and weighs only about 500 g (1 lb). This, with a few additions, could be your basic kit. Incidentally, a folding stool – if you can manage it – is useful, too, and ensures that you always have something comfortable and dry to sit on.

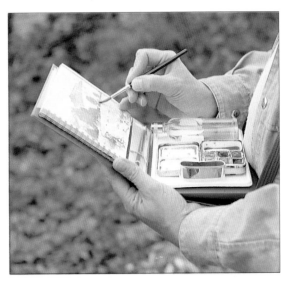

Top: *The large pockets of my painting waistcoat hold everything I need for painting outdoors, except large paper*

Centre: *The Travelling Studio is indispensable for outdoor work – you can even use it standing up*

Bottom: *When it's not in use, everything packs neatly away*

## BRUSHES

It isn't easy to separate colours, brushes and paper into order of importance, but I feel that the brush just must come out at the top of the list. The brush makes the marks and these build up to create a painting, so what type of brush you use and how you apply the paint with it will determine your individual painting style. After all, in painting it is with the brush that you really express yourself on paper, and never more so than in watercolour. A single brush stroke can create a field, a lake, the side of a boat – all kinds of things. Therefore, it is important to know your brushes and what to expect from them.

For watercolour painting, I feel there is only one general purpose brush that a traditionalist would use. It is the best quality – a round sable. This is the most expensive brush on the market but it gives you perfect control over your brush strokes and, if properly cared for, will last a very long time.

Man-made fibres (nylon) are now widely used to replace the sable hairs in artists' brushes and these brushes are much less expensive. Many are sold under brand names, such as the Daler-Rowney Dalon series. If your pocket won't stretch to sable brushes, don't worry. I know professional artists who use nylon brushes for all their watercolour painting and they are happy.

To me, the most important difference between nylon and sable brushes is their water-holding ability. A nylon brush only holds two-thirds of the amount of water held by a sable and, as you read on, you'll find I like to paint using bags of water! However, the smaller sizes of nylon brushes are excellent for detail work, and I always include a nylon (Dalon) rigger brush in my kit. In fact, the three brushes shown here are the only brushes I use for all the watercolour paintings I did for this television series.

## PAPER

Deciding which type of paper to use can be rather confusing at first, since there are so many to choose from. A basic point to remember is that if paper is too absorbent it will soak up paint like blotting paper, and if it's non-absorbent, paint will simply run off! It's best, therefore, to always use paper specially made for the watercolour artist.

Paper is graded according to the texture of its working surface and traditional watercolour paper comes in three distinct surface varieties: Hot Pressed, Rough and Not. Hot Pressed (HP) means the surface is very smooth; Rough is the opposite, giving your painting a textured look; and Not (sometimes called Cold Pressed or CP) is between rough and smooth and by far the most commonly used. The weight or thickness of paper is determined either by grams weight per square metre (gsm) or by calculating how much a ream of paper (500 sheets) weighs. So, if a ream weighs 200 lb (about the heaviest you can use), the paper is so called (with its manufacturer's name and surface type), for example, Whatman 200 lb Not. A good weight of paper is 140 lb (285-300 gsm).

On the opposite page, I give examples of the different papers I have used in the series, with their names, grades and weights. I have also shown what effects a pencil and a brush stroke of colour can give you on each type of paper, reproduced actual size. Apart from the traditional watercolour papers, I've included Bockingford watercolour paper which only comes in one surface but has different weights and is an excellent, inexpensive watercolour paper.

Cartridge paper, also shown, is quite a bit cheaper, too. It has a very smooth surface and is lovely for painting small sizes, say up to 28 x 41 cm (11 x 16 in). It's really worth getting a sketch pad of this because it's the paper most commonly used for drawing, too.

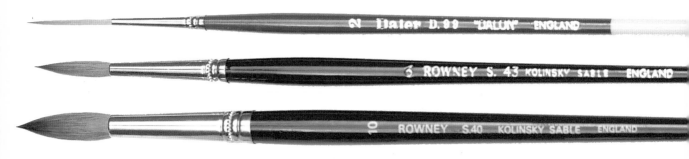

FROM THE TOP: *nylon (Dalon) rigger; No. 6 round sable; No. 10 round sable*

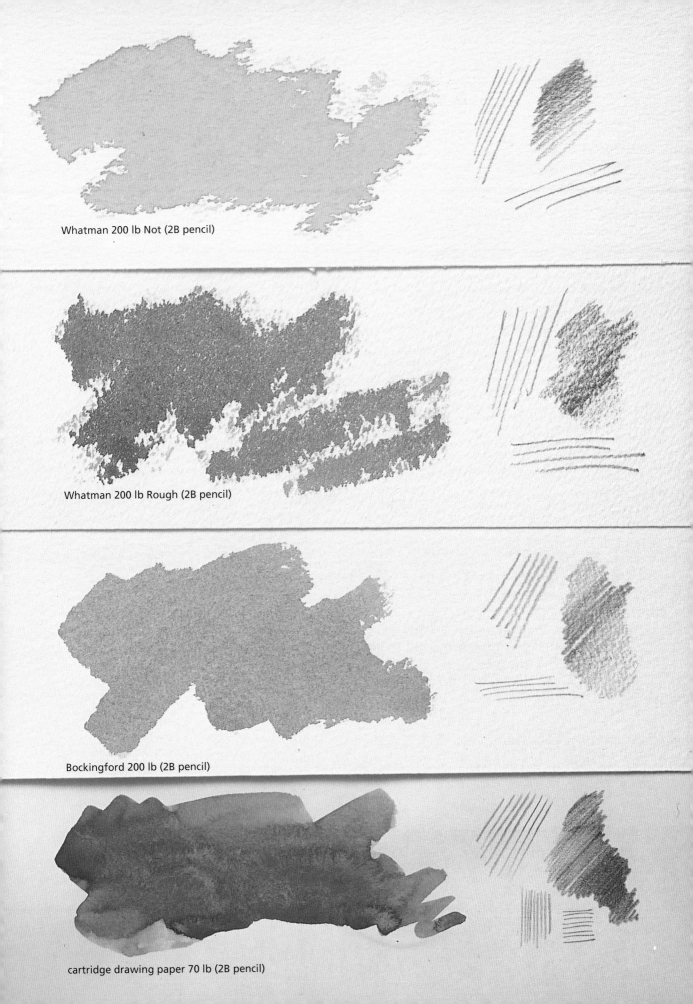

Whatman 200 lb Not (2B pencil)

Whatman 200 lb Rough (2B pencil)

Bockingford 200 lb (2B pencil)

cartridge drawing paper 70 lb (2B pencil)

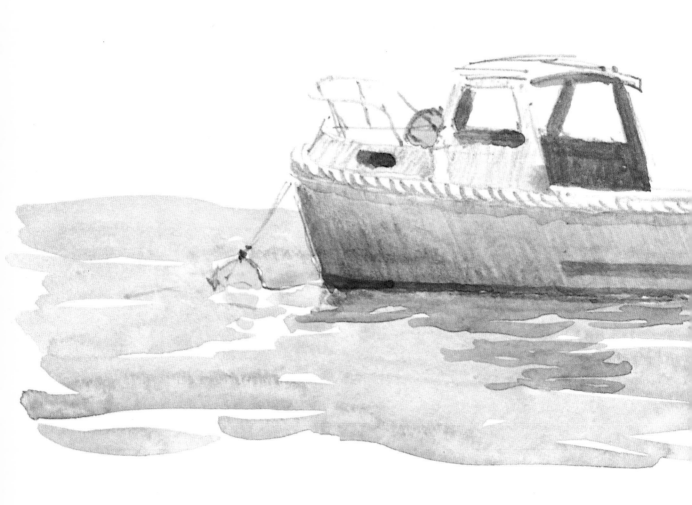

Cartridge drawing paper
(actual size 21 x 29 cm/8¼ x 11½in)

# THE 12 PROGRAMMES

A course of easy-to-follow watercolour painting lessons
to accompany the television series

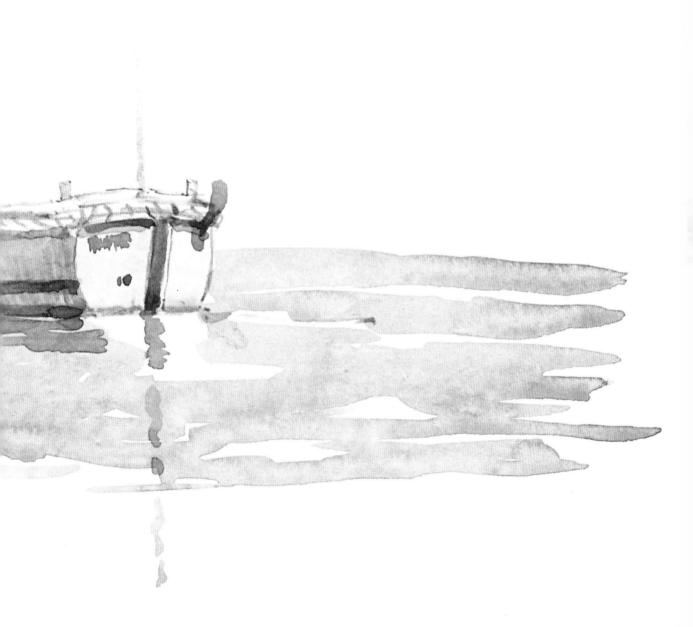

# 1 TOPSHAM

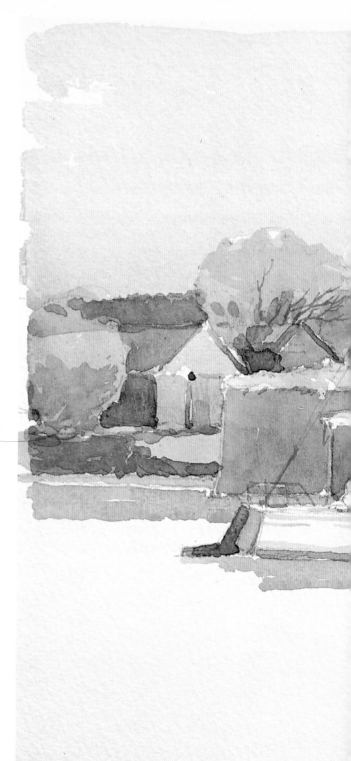

## OBSERVATION

In the programmes that follow, I will go into detail about drawing, colour mixing, choosing a location, composition, tonal values, and the many other aspects of watercolour painting. But first I'm going to talk about observation.

To paint well, you need to look at and see things very carefully. It's one thing to stand on a pavement and casually notice someone go into a greengrocer's shop. But if you had *observed* that same scene in the same time-span, you might have seen a much more accurate picture – that it was a young lady, that she was wearing a yellow dress and that the shop had a dark green painted door and window frames and a bright yellow 'Special Today' sign in the window. You would also have observed that small white van parked at the side of the shop, and the telegraph pole in front with a child's bicycle leaning against it. And when the young lady came out of the shop, you would even have seen the large cabbage sticking out of her shopping bag!

This is *how* you should look at a scene, even before you start to paint it, although naturally you will continue to observe it carefully while you are painting it. If you can train yourself to see like this, drawing or painting your scene will become much easier. In fact, soon you won't have to think about observing because, as an artist, it will become second nature to you!

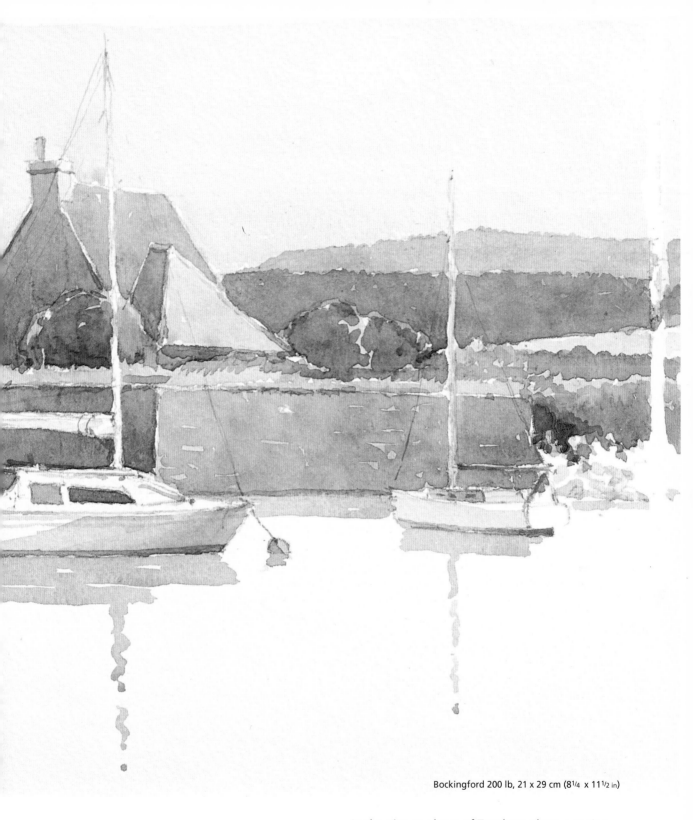

Bockingford 200 lb, 21 x 29 cm (8¼ x 11½ in)

*In the picture above of Topsham, there wasn't a young lady in a yellow dress coming out of the greengrocer's shop, of course! But there were plenty of things that I had to observe to be able to draw and paint it, as I will show you overleaf*

## OBSERVING TOPSHAM

Topsham, in South Devon, is one of my favourite places to paint. I always love painting boats and water, and this was a gorgeous scene.

The first thing you should do when you find a scene is exactly what I did. Sit down, relax and *really* observe it. This will make you familiar with the scene and what you are about to draw. Remember that boats move with the wind and tide, so always decide what position you want a boat in before you draw it. At a casual glance, boats don't seem to move, but when you *observe* them, they can move from a three-quarter view to a broadside view, and one boat can move enough to cover up a neighbouring boat. Usually they move back to the original position again and so, if you are patient, you will see your boat in *your* drawing position at different times during your drawing and painting.

You will see opposite some of the other elements that I had to look at very carefully before and while I was drawing and painting Topsham.

For beginners and students, the most frightening part of any painting is the blank white piece of paper in front of you before you start your work. Even professionals can hesitate at this point! The only way to get over it is to start, no matter how hesitant you may be. Don't worry – once you have some lines drawn on the paper, you will start to relax and feel more comfortable with your work.

*I made a point of observing how high the tall mast went above the top of the cottage roof – compare it to the mast of the smaller boat*

*Notice the definite shape of the rudder*

*Always observe reflections. Study them carefully and then simplify them as I did here*

*I needed to see which direction the sun was coming from. This shows the shadow side of objects – look at the shadow on the chimney stack*

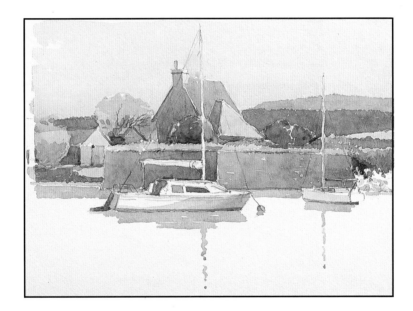

*I observed the height and width of the sea walls, and also the sunlit side and the shadow side of it*

# 2 HAY TOR

## MIXING COLOURS

I went to Hay Tor on Dartmoor because it's an ideal place to show you one of the basic techniques of watercolour – painting a wash. But first it's important to learn about mixing colours.

There are literally hundreds of colours in a landscape, but don't let that worry you. You can get almost any colour you need from just the three primary colours: red, yellow and blue. You can, of course, buy ready-mixed shades of green, orange, purple, brown and so on, but forget these and start with the three primaries.

The colours I use for the series are shown on this page. The primaries I use are Crimson Alizarin, Cadmium Yellow Pale and French Ultramarine. I also use two other primaries, Yellow Ochre and Cadmium Red, and one ready-mixed colour, Hooker's Green No. 1. Just six colours, but these can provide all the tones and colours you need for watercolour painting.

An important rule for mixing colours is to put the predominant colour that you are trying to create into your palette first. For a yellowish-orange, start by putting yellow into your palette, then add a little red. If you reverse the process, you'll find that the red overpowers the yellow, and the result is a reddish-orange instead. By following this simple rule from the start, you'll avoid a lot of extra mixing, ruined paintings and frustration!

Since watercolour paint is transparent, the only way to make a colour lighter or paler is to dilute the pigment by adding water. To make a colour darker, you simply do the opposite and add more

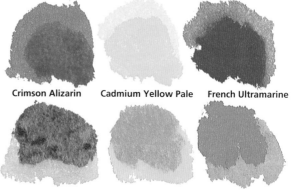

Crimson Alizarin     Cadmium Yellow Pale     French Ultramarine

Hooker's Green No. 1     Yellow Ochre     Cadmium Red

paint. In the colour chart opposite, I have started with my three primary colours, added water to them to make them paler, and then mixed them to show you some of the basic colours that can be obtained by mixing just two or three primary colours. Then I have added Hooker's Green No. 1, and I've also shown you how to mix a 'black' by using the three primaries together. In this case, the first colour must be blue, since it's the darkest, then add red and then add yellow. To make it grey, add more water. I don't use ready-mixed Black and would recommend you avoid it, too, especially at the beginning. It can become a short cut to darkening colours but will only make them 'dirty'. You'll get far better results if you find out what your primaries can do for you.

Some people are born colour mixers, while others find it a little difficult at first. But, with practice, it's something we can all do. So, have a go – sit down with your paintbox, brush and a clean sheet of cartridge paper. Try mixing the colour of the wallpaper, the cushion – anything you can see!

# THREE PRIMARIES

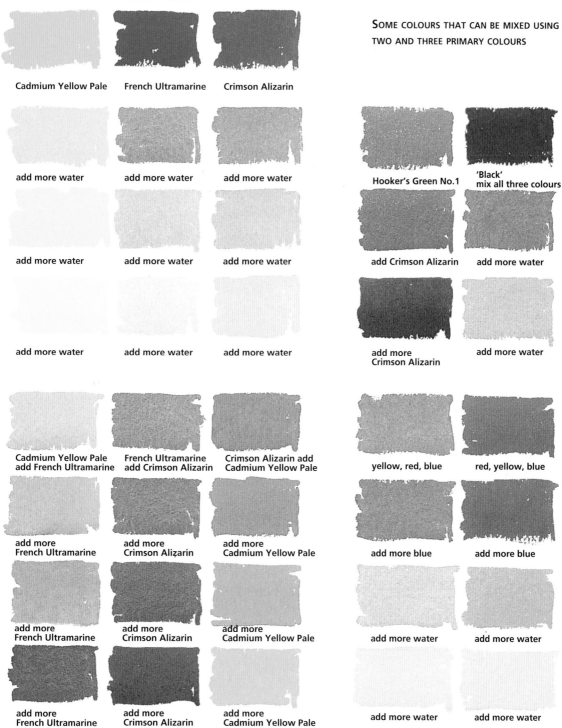

Cadmium Yellow Pale    French Ultramarine    Crimson Alizarin

add more water    add more water    add more water

add more water    add more water    add more water

add more water    add more water    add more water

Cadmium Yellow Pale add French Ultramarine    French Ultramarine add Crimson Alizarin    Crimson Alizarin add Cadmium Yellow Pale

add more French Ultramarine    add more Crimson Alizarin    add more Cadmium Yellow Pale

add more French Ultramarine    add more Crimson Alizarin    add more Cadmium Yellow Pale

add more French Ultramarine    add more Crimson Alizarin    add more Cadmium Yellow Pale

SOME COLOURS THAT CAN BE MIXED USING TWO AND THREE PRIMARY COLOURS

Hooker's Green No.1    'Black' mix all three colours

add Crimson Alizarin    add more water

add more Crimson Alizarin    add more water

yellow, red, blue    red, yellow, blue

add more blue    add more blue

add more water    add more water

add more water    add more water

## PAINTING A WASH

Learning how to paint a wash is one of the most important and fundamental lessons in watercolour painting. Basically, it is the ability to apply paint on to the paper, and you can use this technique to cover the whole of your paper or just a tiny area.

The first and most vital thing is to have your board in the right position, with a nice lean to it. If you try to work with your paper flat on your knees, paint will 'blob' and it won't run down. And you do want it to run down a little – this is the way a wash is created.

Some artists use an easel and have the paper perfectly upright but when it's in this position you have to accept that you have very little control – it's a very free way of painting. To try these washes, and keep things in control, use the orthodox method and have your board at a slight angle, about midway.

Apart from having your board at an angle, the secret of applying a wash is to use a lot of water. If you don't, you will find it impossible to put on a wash. Start by mixing plenty of watery paint in your palette and load your largest brush with it.

Always start at the top left-hand side of the paper, if you are right-handed, taking the brush along in a wide, even stroke. You'll notice a reservoir of paint is left underneath but don't panic or rush. If your paint runs down the paper 'out of control', your board is at too steep an angle. When you reach the end of the stroke, simply lift your brush off the paper, bring it back to the beginning, and start another stroke, running along the bottom of the first wet stroke. Continue down the paper in this way, adding plenty of paint to your brush as you need it; don't let it get dry. When you mix the paint first and don't add more water or paint to the mix, the colour density remains the same throughout the wash. This is called a *flat wash*.

Now try a *graded wash*. With this, you start in exactly the same way as you do for a flat wash but, as you paint downwards, you add more clean water to your paint in the palette before each brush stroke. Since this makes the colour weaker, your wash will gradually grow lighter in colour. In fact, if you keep adding water and your paper is long enough, the wash will finally begin to disappear at the bottom.

Another thing that you can do with a wash is to change the colour of it as you work down. In the last example opposite, I've started off in blue and then, between strokes, added red to my palette. You'll see that, as the new colour is added, the wash gradually changes colour, too. Then I've gone redder still, all the time adding bags of water to keep the wash running down the page nicely. Lastly, I've added yellow, changing the colour all the time between brush strokes, but always doing it evenly. This type of wash is particularly effective when painting cloudless skies and sunsets, something I love to do.

## PAINTING TIPS

- Always use plenty of water

- Start at the left and finish the brush stroke on the right of the paper

- Always have your board tipped at an angle

- Have your board at a steeper angle if you want the colour to mix more quickly

- Where you don't need a perfectly flat wash (the sky with clouds, for instance), work your brush in all directions – this is quite correct

OPPOSITE: *Examples of washes – a flat wash (top); a graded wash (centre); and changing colour in a wash (bottom)*

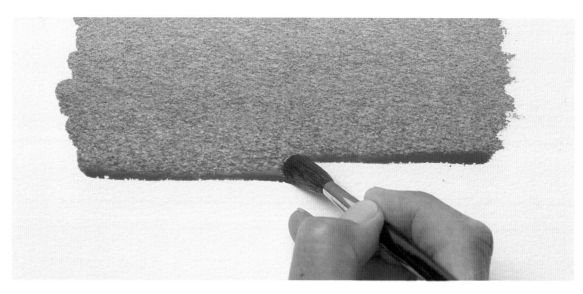

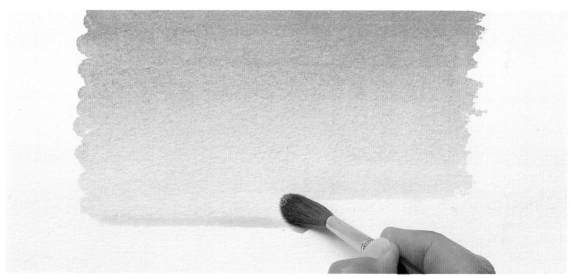

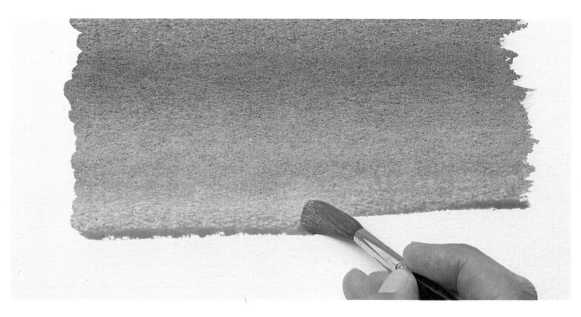

## PAINTING HAY TOR

I drew in Hay Tor with my 2B pencil on Whatman 200 lb Not surface paper. Before I started to paint, I had to decide whether to paint the rocks darker or lighter than the sky. Rocks become lighter when lit by the sun but, when the sun goes in, they look darker than the sky. That day was overcast, so the decision was made for me – to paint the rocks dark!

A subject like Hay Tor is very good for practising washes, as you have to paint your washes to definite shapes. I started by painting a wash for the sky, mixing French Ultramarine, Crimson Alizarin and a little Yellow Ochre. I painted up to the rocks and ground at the top of the hill. Then I mixed a wash of Yellow Ochre and Crimson Alizarin and painted over the hill and footpaths. Remember, when you mix a wash, to make sure you mix enough to cover the area you wish to paint.

Next I painted in the rocks, leaving little bits of white paper showing through for the light areas of the rocks and using a mix of French Ultramarine, Crimson Alizarin and Yellow Ochre. I didn't worry if my paint ran into the wet paint of the ground – in fact, this can help a painting. But be careful not to let it run into the sky if that is still wet.

I then mixed a stronger wash of 'ground' colour and painted over the hill again, making sure that my first wash was dry. I painted from the top downwards, adding green to my wash as I worked down the paper. I didn't paint the paths, except for the second from the left. When the rocks were dry, I painted over them with a darker wash, leaving some areas unpainted to represent cracks and crevices. Then, when this was dry, I painted in the dark areas on the rocks with my No. 6 brush to give them more form and dimension. Finally, I painted a wash of stronger colour over the hill (not over the paths) and painted in the figures.

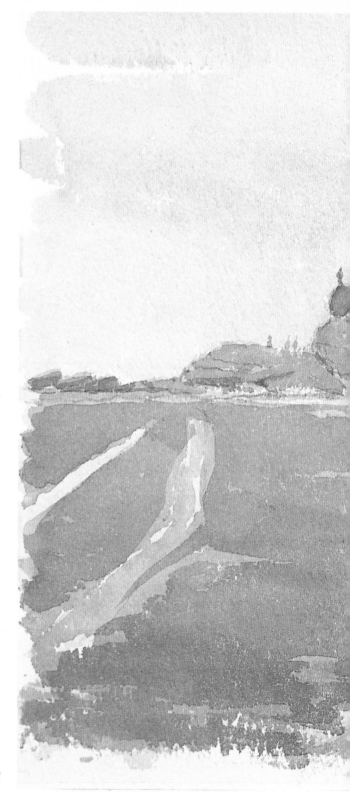

RIGHT: *Dark areas of the rock formation were painted in with a No. 6 brush (brush stroke K, page 29)*

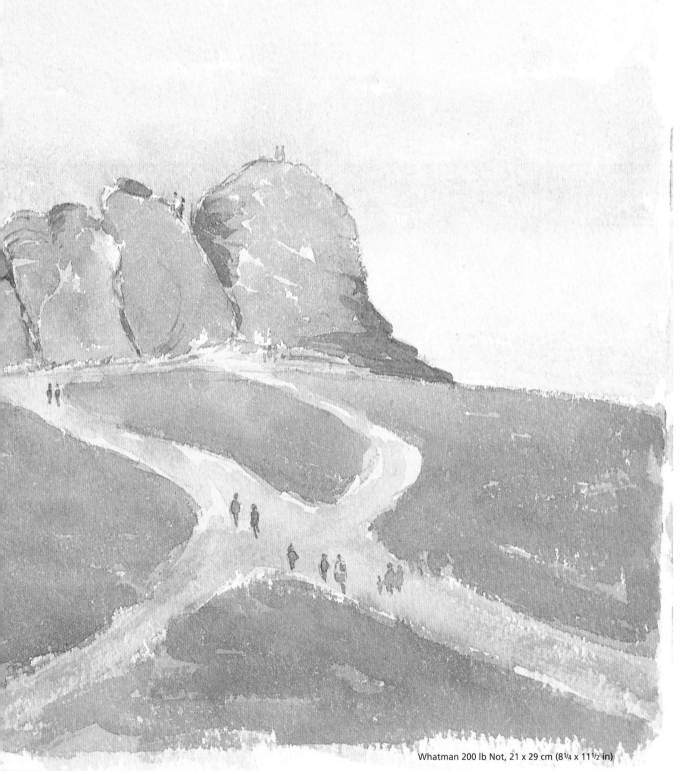

Whatman 200 lb Not, 21 x 29 cm (8¼ x 11½ in)

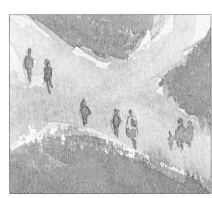

RIGHT: *Paint figures very simply. These are only suggested, just giving an illusion of people (see page 67).*

# 3 HOUND TOR

## BRUSH STROKES

For this programme, I visited Dartmoor again. Hound Tor is an inspiring location and perfect for demonstrating to you what the brush can do.

Although it is possible to make hundreds of variations on different brush strokes, I have shown you just 12 on the following pages, first using my No. 10 brush and then my No. 6 brush. (If you've already read the Materials section, you'll know that, apart from my nylon rigger, these are the only *two* brushes I use!)

If you master these basic brush strokes, you will have as much brush control as you need, and will then be able to use your own ideas to vary them. And remember, each mark can be created differently by adding more water to your brush, and you can use any size brush for any brush stroke.

Don't worry if you find some of these brush strokes a little difficult at first. If you practise them, they will soon develop. Start with any brush and any paper – and experiment to find out all the wonderful things your brush can do!

## PAINTING TIP

When painting, use your little finger or the side of your hand to support your brush hand by resting it against the paper. This will allow you to control the pressure of your brush on the paper

### USING A NO. 10 SABLE BRUSH

**A** This is the natural line your brush will make when you paint horizontally using medium pressure

**B** The brush is held differently here, more like a pen. I use this stroke when I want to keep a **definite top line**. The underside is uneven

**C** This is the **dry brush technique**. Load your brush with just a little paint (dry it out a bit on the side of your palette), so that it will start to run out during the brush stroke to create a 'hit-and-miss' effect. You will need a lot of practice before you are able to judge how much paint to use, so do keep at it!

**D** A good brush can cope with this sort of rough treatment, which gives a **spiky grass effect**, without any problem. Push the brush hard on your paper and then push it upwards and downwards, letting the brush hairs splay out in all directions. You will automatically get dry brush effects when doing this and I use this technique a lot in landscape painting, for foreground grass and hedges, etc.

**E** Use this stroke for **filling in a small area** when three sides are to be kept within a given shape, i.e. chimney stacks

**A**

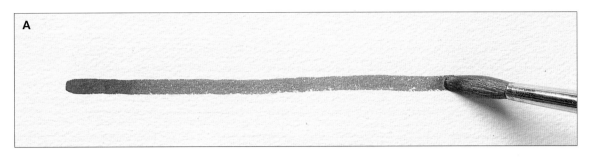

**B**

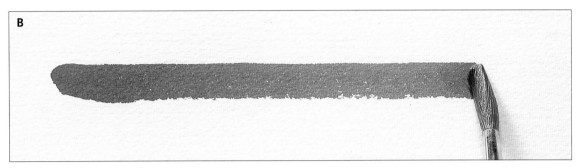

**C**

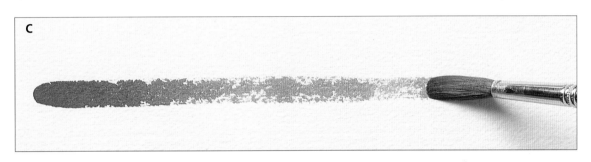

**D**

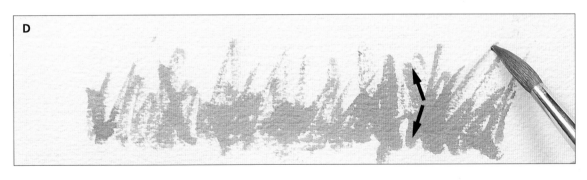

**E**

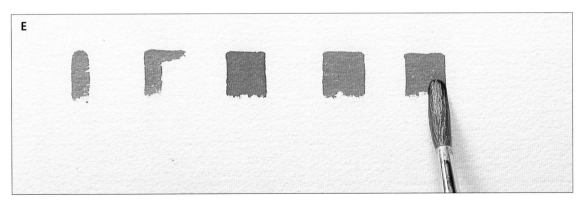

**F** This is the same brush stroke as A, except that it is painted with a No. 6 brush. It is a **general purpose brush stroke** and therefore both versions are very important. (Use your No. 6 brush to practise brush stroke B as well.) It is also important to learn how to vary the pressure of your brush as it is moving across the paper. Try this stroke again, but this time start with more pressure and, as the stroke progresses, gradually lift the brush off the paper

**G** This takes stroke F a step further. Load the brush and paint a **continuous line**, while at the same time varying the pressure of the brush. Remember to have enough paint on your brush to take you through the whole stroke!

**H** These **thick and thin vertical strokes** will help you use your brush effectively for small work. Follow the arrows and when you have done this exercise (moving only your fingers), repeat all the strokes but make them longer (this time moving your arm)

**I** This **random dry brush** effect is similar to brush stroke D, except that the brush is moved from right to left and left to right. Push down the ferrule end of the hairs and let them splay out as you move your brush backwards and forwards

**J** Use this stroke for **filling in larger areas**. First paint four distinctly separate strokes to give you a rectangle. Then fill in the area quickly with paint. And remember, your first brush strokes must remain wet while you're doing it, or you will end up with a darker line around the edge of the rectangle where your first brush strokes have dried out

**K** This last stroke is really an extension of brush stroke J. It may look like a doodle, but it's one of the most important strokes of all. I use it for **filling in irregular areas** and moving on to other areas, filling them all in with colour. When you have mastered this technique, you will feel very much more at home with your brush. Mix plenty of paint first – the secret is to keep it watery!

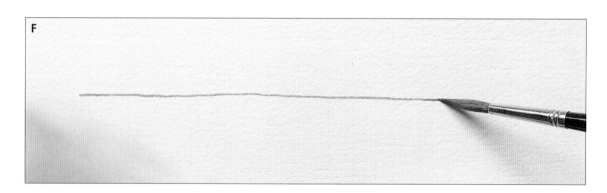

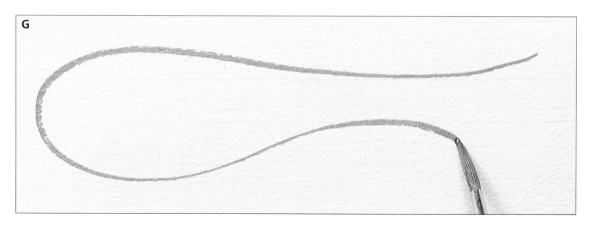

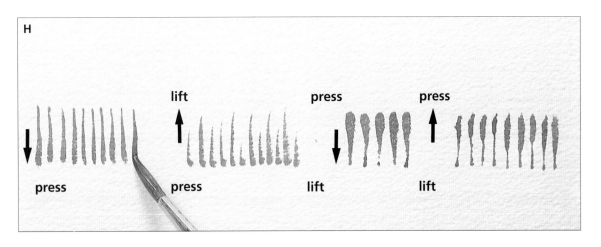

H

press · lift · press · press
press · press · lift · lift

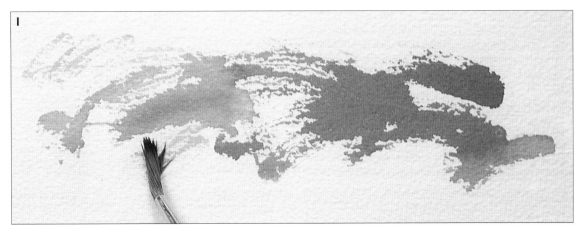

I

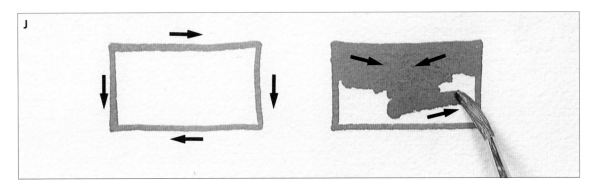

J

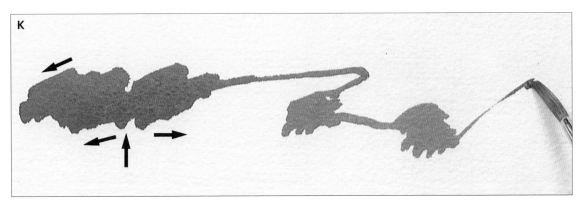

K

## PAINTING HOUND TOR

The most important decision I made before I started this painting was to leave the side of the first cottage as unpainted white paper. This helped to give the illusion of sunlight in the painting. It also made the cottages look three-dimensional, but I'll tell you more about that in Programme 6.

I was actually quite surprised how *green* this painting turned out, but then it was a very green subject with nearly all land and only a small area of sky. When I painted the background hills down towards the cottages, I made the colour greener to paint down behind the trees. This was really a simple wash that changed colour. It was a warm day and the paint was drying quickly so, naturally, I had to use *bags of water!*

I worked the trees very simply, without much detail or fiddling, but I did add some trunks and branches with my No. 6 and rigger brushes. Notice how the trunks help with the form of the trees on the right of the cottages.

I worked the foreground very simply, letting my dry brush strokes give the impression of rough grass and rocks. When this was dry, I painted a shadow on the areas I had left white for the rocks.

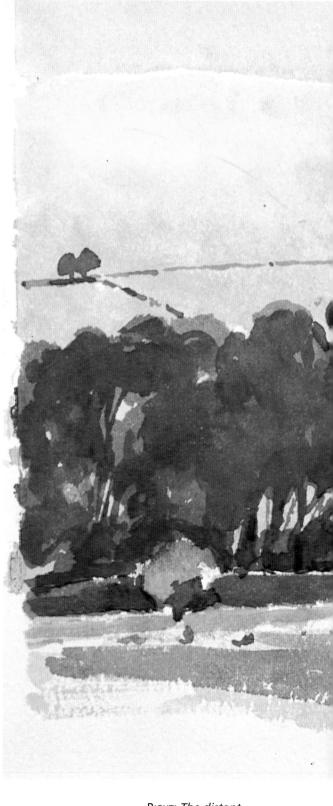

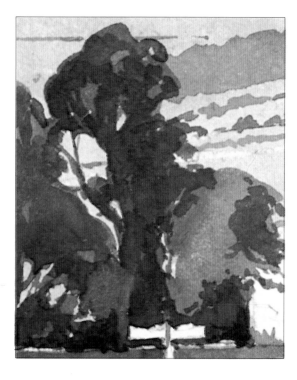

*The large trees were painted with brush stroke I; their trunks with brush stroke K. I painted up to the bottom edge of the signpost using my No. 6 brush and brush stroke B*

RIGHT: *The distant hedge was painted in with my No. 6 brush, using brush stroke F. I then let the brush 'hit-and-miss' as I painted in the hedge*

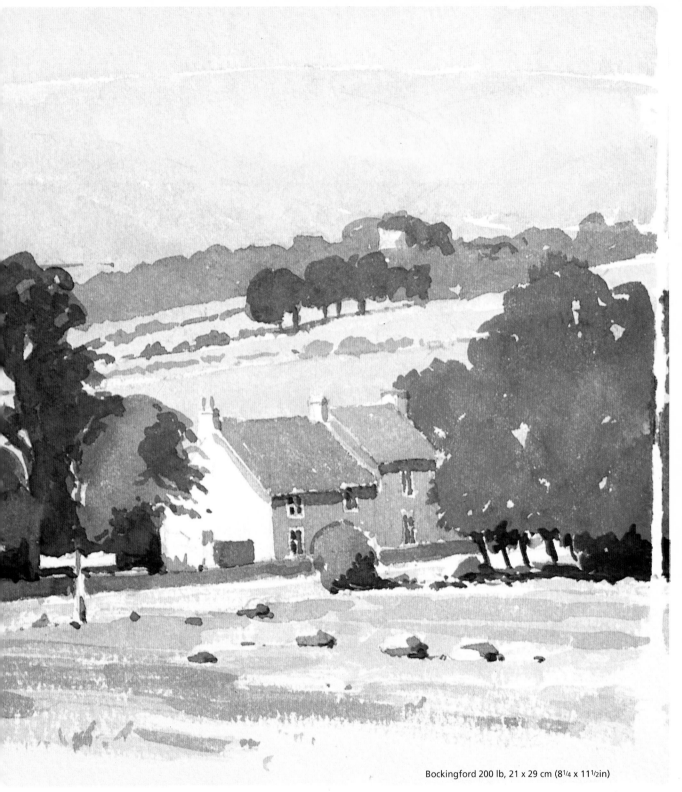

Bockingford 200 lb, 21 x 29 cm (8¼ x 11½in)

RIGHT: *Brush stroke K was used for the hedgerows*

# 4 DAWLISH WARREN BEACH

## COMPARING PAPER

In the Materials section of this book, I've explained about the different grades of paper. If you are a beginner with watercolour, it's a good idea to get used to two or three different types, learning how each one reacts to paint and exactly what you can and can't do.

The beach at Dawlish Warren provided me with an ideal spot to demonstrate what happens when you paint the same scene in watercolour on two entirely different surfaces of paper. My first painting (shown on this page) was done on cartridge drawing paper, which has a very smooth surface texture. Compare this with my second painting (shown overleaf), which was done on a traditional Rough watercolour paper, and you'll see two quite different results.

### First Painting: on Cartridge Paper

Cartridge paper is ideal for drawing on but it's a particularly useful paper because you can paint on it, too. The smooth texture means the brush glides along it easily, without obstruction.

When you're using cartridge paper, paint will tend to run. Don't worry. Look at how some of my hills in this painting run back on themselves. It really doesn't matter because it's all part of it and adds to the final effect.

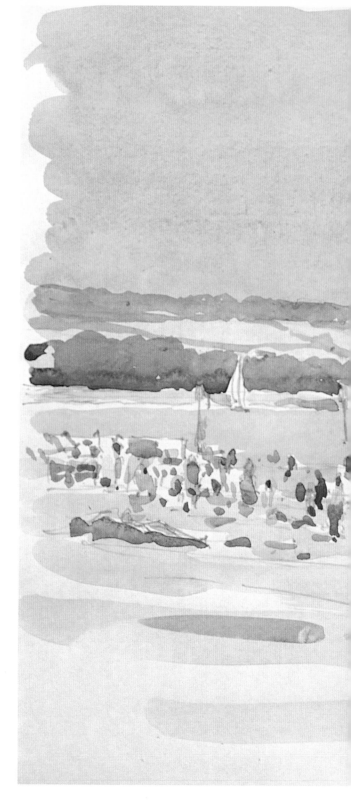

FIG. 1: *The paint covered the cartridge paper very easily, especially when applying the wash for the sky*

FIG. 2: *On the Rough watercolour paper, paint was harder to put on. Notice how I left some small areas of paper unpainted in the sky*

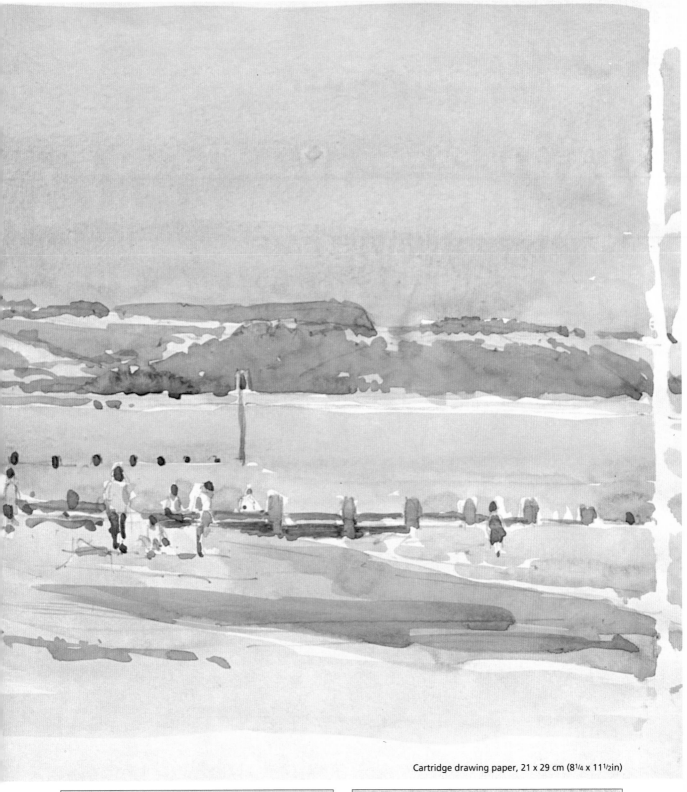

Cartridge drawing paper, 21 x 29 cm (8¼ x 11½in)

FIG. 1:

FIG. 2:

## Second Painting: on Rough Paper

When painting on Rough paper, the two main things you notice are that the paint doesn't run and the brush doesn't move as easily as it does on a smoother surface. This paper really is *rough* and your brush will tend to have a 'hit-and-miss effect', as some of the paper receives paint and some doesn't. The result is that you get some nice white areas left behind – this is marvellous for giving the illusion of ripples on water, for example.

In fact, nothing appears smooth about this paper, so don't aim for neat, clean lines. It's best to let the brush dance around and make things happen as you go along – you'll notice that the painting I've done has an almost dotted effect.

Another plus with this paper is that you can work over existing paint to add darker tones, or lift colour off by working a brush (no paint, water only) into painted areas. I did this with some of the trees. This is something you can't do on cartridge paper, where it would make the paint look murky or dirty. However, on Rough paper it looks good and can help to mould the picture together.

Now that you've seen what working on two different papers can do, it's your turn to experiment! Once you've tried a paper and got used to it, you'll be amazed at the confidence it will give you. Remember that only by practising and getting to know your materials really well will you be able to discover which one – in which situation – works best for you. Once you have, you will be well on the way to mastering watercolour painting.

Go on, have fun – you can do it!

## PAINTING TIP

Whenever possible, start painting from the left-hand side of your paper, so that you've got a dry area on which to rest your hand. Otherwise you might get into trouble because you'll be trying to work over wet paint. (Of course, if you're left-handed, you'll need to do the opposite!)

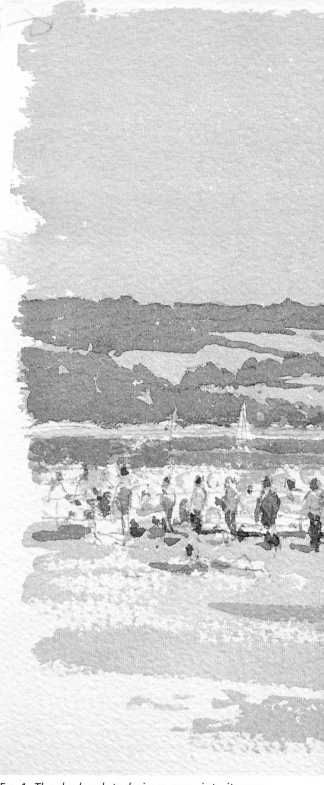

FIG. 1: *The dry brush technique came into its own here on the sea. The Rough paper allowed areas of paper to remain unpainted, helping to give a look of sparkling sunlight on water*

FIG. 2: *On cartridge paper, you can't get the same effect. The sea had a wash painted over it, but the paint covered all the paper, leaving no unpainted paper to represent sunlit water*

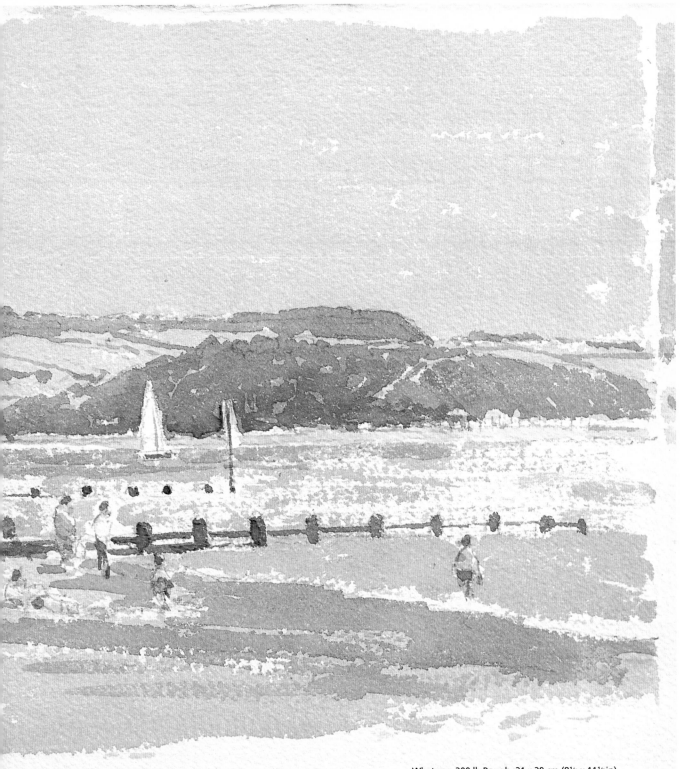

Whatman 200 lb Rough, 21 x 29 cm (8¼ x 11½in)

Fig. 1:

Fig. 2:

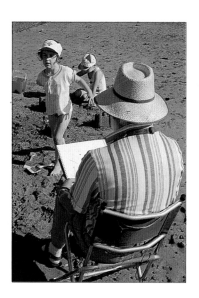

## QUICK SKETCHES

The beach is an excellent place for observing and drawing people. In between painting at Dawlish Warren, I decided this was the perfect opportunity to practise some figurework – and out came my cartridge paper again!

The biggest problem with both animals and children is that they tend to move around rather a lot. Of course, with repetitive tasks like building sandcastles, there's a good chance they may come back into the same position again, but don't count on it! The main trick is simply to keep going, endeavouring to keep in your mind's eye what you've just seen seconds before. If you can't manage it, don't worry about abandoning one sketch and starting a new one – you'll see I've done this myself in a few places. Try to draw simply and, as your confidence grows, you can put more modelling into your figures.

I finished by working over the sketches I was happy with, using simple washes. On cartridge paper, the paint will run – but it doesn't matter. The appeal of adding colour to this particular paper is the spontaneous, free watercolour effect you get.

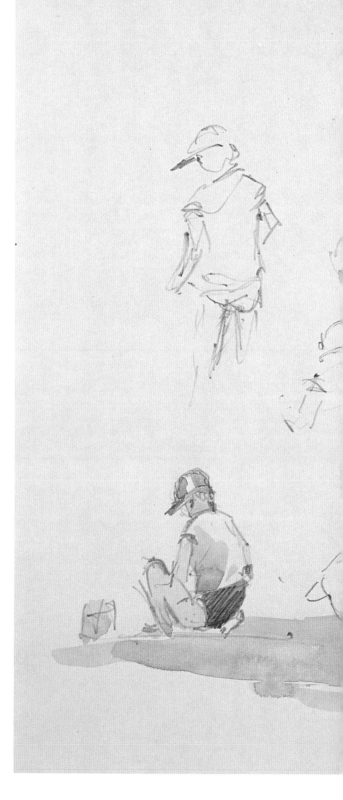

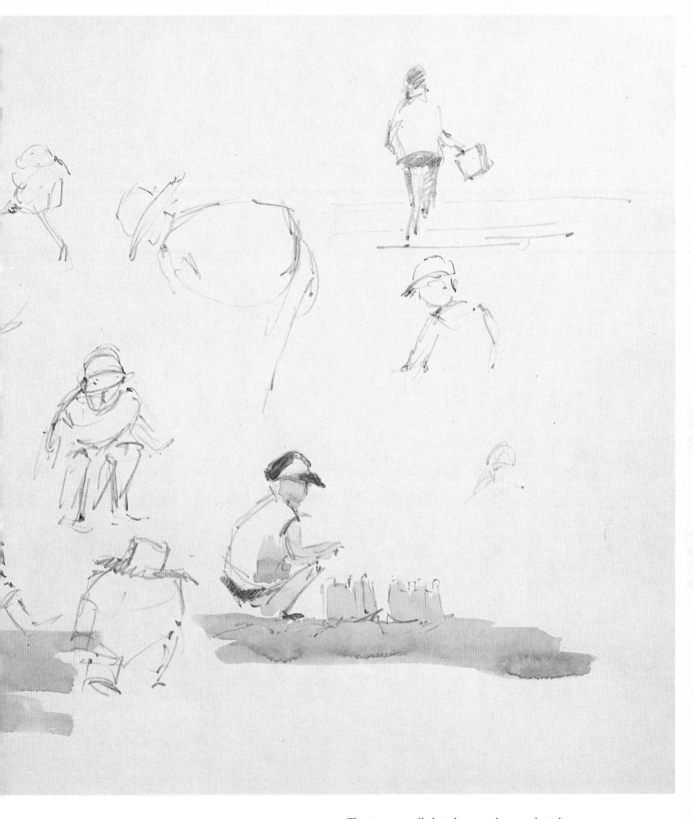

The top pencil sketches are incomplete because
the figures moved away before my brain and
pencil had co-ordinated to work fast enough.
After 5-10 minutes of sketching, I usually find I
can cope quite well – but not always!

# 5 HARPFORD

## CHOOSING A LOCATION

Harpford, in Devon's Otter Valley, is another gorgeous spot – in fact, I was almost spoilt for choice when I went looking for a location!

Finding a painting spot can be one of the most frustrating parts of working outdoors – and that goes for professional artists as well as beginners. This is one time when you need plenty of self-discipline, so here's a good tip. When you are in the area you want to paint and you start to search for a suitable spot, *always* choose the first scene that inspires you – that's the one to start painting. If you don't choose that one, you could very easily fall into what I call the 'round-the-next-corner trap'. This really is a recipe for disaster because, all the time you're searching for something better, you will become more and more indecisive – and also your painting time will be running out. So try to find a place that gives you inspiration, make your decision and *stick* to it. Forget what may be round the corner – leave that discovery for another day!

## SELECTING A VIEW

Even when you've found your perfect location, you will have one more decision to make before you put pencil or brush to paper. Exactly *what* part of the scene before you are you going to paint? Particularly if you're looking at a fairly complicated scene, such as a village square, or a large one, such as a landscape, it can be yet another thing to be indecisive about – after all, you're being presented with a whole panorama!

One clever way to help you stop worrying is a simple device called a *picture finder*, and I would suggest you always carry one with you in your kit. You can make one quite easily by cutting a mask out of thin card with an opening of about 6.5 x 4.5 cm (2½ x 1¾ in).

Hold the picture finder in front of you at arm's length, close one eye and look through the window. You will see that the picture finder has given you a definite area from whatever is in front of you, in the form of a framed picture. If you move the picture finder slowly up and down and nearer to you, you will see many different compositions of the same scene through the window. Simply move it around until you find the composition that really inspires you. Then make mental notes of where your arm is and where the key points of the scene hit the inside edge of the mask, and mark these on your sketch pad to give you guidance.

My picture finder, which is now on the market, has four lines printed on the transparent window. These divide the picture up into thirds, both vertically and horizontally. These lines will help you further with positioning objects from the real scene accurately on your paper.

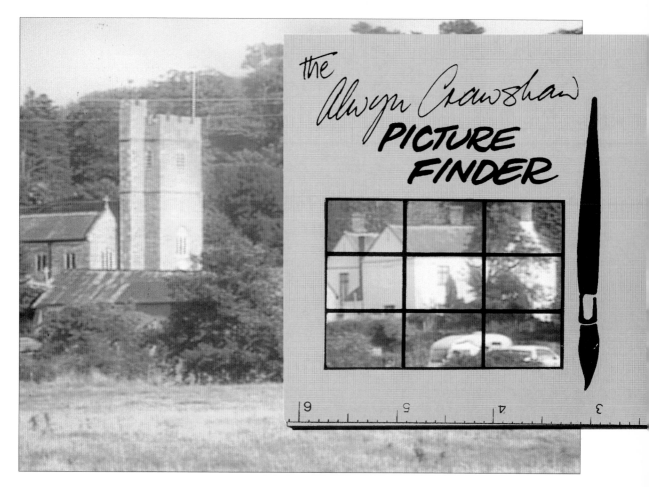

*the* **Alwyn Crawshaw PICTURE FINDER**

*This was a nice scene but lacked enough interest for a pencil sketch. What really inspired me was the view above, as seen through my picture finder, and that's what I quickly decided to do. You can see my finished pencil drawing on page 44*

Now that you know how to choose your location and select a perfect view, it's time to take a closer look at the drawing side of painting!

To be able to draw well is a boon for any artist and improving your technique will add a lot to your painting ability, enabling you to tackle much more complicated subjects. As with all things, you need to get bags of practice. But that's fine, because one of the best things about drawing is that you can pick up a pencil and draw something almost any time, any place and anywhere! There's no need for a lot of expense, either – for a basic sketching kit, all you need is a 2B pencil, a sketch pad and a putty eraser, and you're well on your way.

# DRAWING WITH PENCIL

Your pencil is, of course, your most important piece of equipment for drawing and, like brushes and colours, you'll find plenty of different ones to choose from. Don't be confused, though – for general sketching purposes you only need two.

A good artist's drawing pencil comes in 13 degrees of lead. HB, one of the two pencils I use, is right in the middle of the scale. On the H side, the leads become harder and lighter as they reach the top of the scale, i.e. H, 2H, 3H, 4H, 5H and 6H (the hardest); and on the B side the leads become softer and darker, i.e. B, 2B, 3B, 4B, 5B and 6B (the softest). For my second pencil, I find 2B is ideal. Start with an HB pencil and a 2B pencil – they are all you need for successful drawing. But if you want to experiment with other grades of pencil later, that's fine too.

The next golden rule for drawing is always to have your pencils sharpened correctly. Let's get straight to the point – they should *never* look like the first pencil in the picture below. You won't feel any artistic flair if you use a pencil like that! Make sure your pencil always has a long, tapering point like the pencil in the centre of the picture. This means that you can use either the point or the side of the lead for shading. When you sharpen your pencil, use a sharp knife to cut off controlled and positive slices, giving a long taper to the lead.

On the opposite page I have shown you the three most important ways of holding your pencil for drawing. The top picture shows what I call the *short drawing position*. This gives you maximum control over your drawing and you hold your pencil in exactly the same way as you would a pen for writing. For this, as with painting vertical or horizontal lines with your brush, move only your fingers for short lines, your whole arm for long lines.

The *long drawing position* shown in the middle picture allows a freer and more flowing movement and the versatility you need to work over large areas. For this you must hold the pencil at least 5 cm (2 in) from the point.

The bottom picture shows the *flat drawing position*. This is a totally different way of holding your pencil, which is almost flat on the paper, held off by your thumb and finger. Use this method to work fast, free, broad strokes, using the long edge of the lead to give large shaded areas.

There are, of course, infinite versions of the three different positions I have shown you. Use them as a base, learning how to draw with your pencil and make it work for you. Practise whenever you can. Doodle – do anything! Don't worry about drawing, just get used to the pencil and what *you* can make it create on paper.

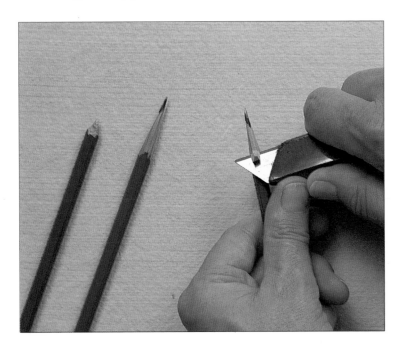

LEFT: *The wrong and right ways to sharpen your pencil*

RIGHT: *Holding your pencil. The short drawing position gives you most control (top); the long drawing position gives freedom to your strokes (centre); the flat drawing position allows maximum freedom of movement (bottom)*

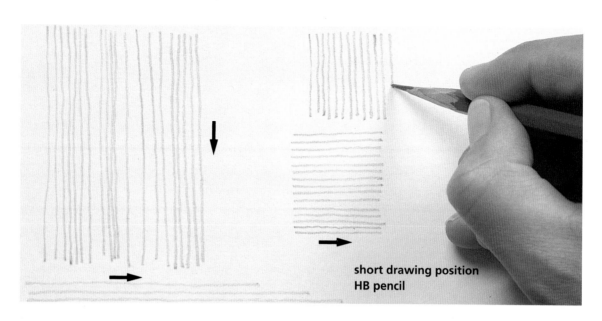

short drawing position
HB pencil

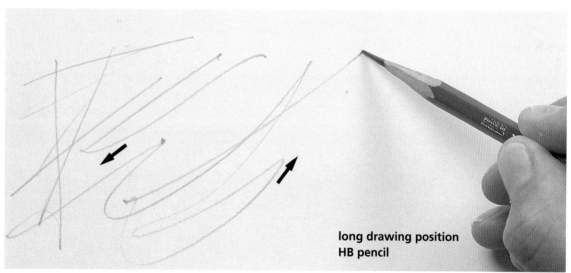

long drawing position
HB pencil

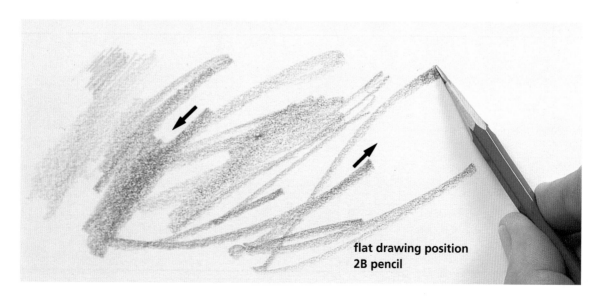

flat drawing position
2B pencil

# DESIGN AND COMPOSITION

I have called this section Design and Composition because to me, in painting, they mean exactly the same thing. This is to say, the positioning of objects on paper in a 'happy' way that enables you to tell a story visually to the onlooker.

Let us start with a very old system I was taught at art school, which is now second nature to me. Use it as a good rule of thumb, but remember that occasional unexpected deviations can also make interesting and original pictures. In Fig. 1, I have divided the paper into thirds, vertically and horizontally, in the same way as lines have been printed on my picture finder on page 39. The four points at which these lines cross (shown as A, B, C and D) are accepted as the four places on a painting where the focal point is best positioned. Therefore, if your centre of interest is positioned on or around a focal point, you should have a good design. Figs. 2 to 5 show how I used the church steeple at Harpford to design different pictures using different focal points.

Another basic design, where the centre of interest is positioned in the top part of a pyramid,

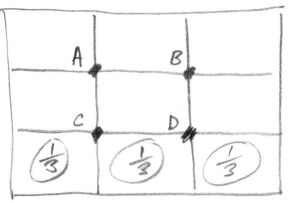

FIG. 1

is shown in Fig. 6. I based *Brixham Harbour*, on pages 78-79, on this design.

When you are sketching, start by putting in your centre of interest at your chosen focal point, then work away from it. You will find that nature's lines (hedgerows, rivers, roads and so on), if observed carefully, will help bring the picture together and form a natural design. To start with, put in everything you see. Later, experience will tell you what, if anything, to leave out. And don't be tempted to distort a view to get more on to your sketchbook. If you do, the design and the objects in relation to each other will look wrong.

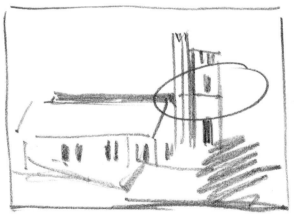

FIG. 2 *focal point B*

FIG. 3 *focal point C*

FIG. 4 *focal point A*

FIG. 5 *focal point D*

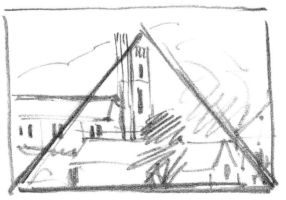

FIG. 6 *pyramid*

## Measuring

At this point you may know what you want to draw, but how do you work out the relative sizes and positions of objects in your scene, and transpose them *accurately* on to your paper? If you learn how to 'measure' now, drawing will soon become a pleasure. It is a very important skill to acquire. Although to start with you may find measuring tedious, or even feel it is a little too mechanical, you *must* persevere. It will become second nature and is as much a part of drawing and sketching as putting pencil to paper.

The principle is simple. Hold your pencil at arm's length, vertically for vertical measuring and horizontally for horizontal measuring, with your thumb along the near edge as your 'measuring' marker. Unless you keep your arm at the same distance from your eye while measuring objects in the same composition, the comparative measurements will not be in proportion, so hold your arm straight – it is then easy to find the same position each time.

When measuring, you simply need to establish the correct proportions of the objects; so let me take you through an example. Let us assume that the sketch below is a row of real houses all the same size, and you only want to draw the third, fourth and fifth houses on your sketch pad. The first thing you must do is decide on a *key measure*. This is any line between two points in a real life scene. In this exercise, I have taken the width of one house. If I apply this measure (which I got by measuring with my pencil, using my thumb as a marker, at the real house) to any part of the real life scene, then I will know how long, tall or small an object is in relation to the width of the house (the key measure).

Because you only want three houses in the picture, draw the first house where you think it might go. Then draw two more the same width, one on either side. If they are too small or too large for the paper size, rub them out and start again. The first lines on your paper when you are working out sizes are not always going to be correct – this happens even with the professionals – so adjust the size of your first house until the other two fit your paper. When you are measuring, don't be too rigid. If an area of your subject measures a key measure and a bit, then draw it on your sketch the size of a key measurement and a bit.

This all sounds very simple and the principle is, but naturally the more complicated the subject, the more you have to work at measuring. For instance, on a town scene you may find you want two or three key measures to help with all the different sizes of buildings you have to cope with. You may decide to use the size of a window as well as the width of a house for a second key measure, and so on. This allows you to measure smaller objects more easily.

Please read this section thoroughly until you understand the method. Try it when you are sitting at home; you will soon get used to it. Frequent practice will train your eye to see the size of objects in relation to each other, and enable you to place them on your sketch pad accurately. It will soon become second nature!

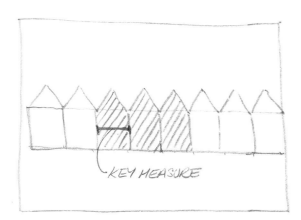

Fig. 7 *'Real life' scene*

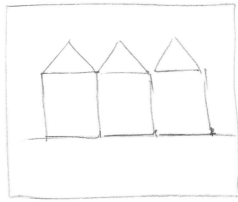

Fig. 8 *Sketch pad*

## DRAWING HARPFORD

With a reasonably complicated scene like Harpford, the first thing I try to do is to sit and relax and observe the scene to make myself familiar with it. This is very important – even if a television crew is waiting for you!

I started the drawing with the church tower, as this was the most prominent object in the scene. Then I positioned the other main elements. At this stage, you can find yourself starting to fiddle a bit and putting in detail. Avoid this. There is no point in drawing a church tower in brilliant detail and then finding you have drawn it too big or too small when you come to draw the rest of the picture! Always draw the *whole* of the scene in before thinking of putting in any detail. Just draw it in outline without putting any shading in at this stage.

When I had done this, I took a short break. Then I looked at the drawing and the scene again with a fresh eye. This is important because it is easier to see areas that aren't quite right and you can correct them before you start to shade in the drawing. Like all drawings, I had a few worries while I was doing it, but when I had finished, I was happy with it.

Finally, I began shading, starting from the top of the drawing. Where possible, always work from the top to the bottom of a sketch. This enables you to rest your hand on the paper without smudging your drawing.

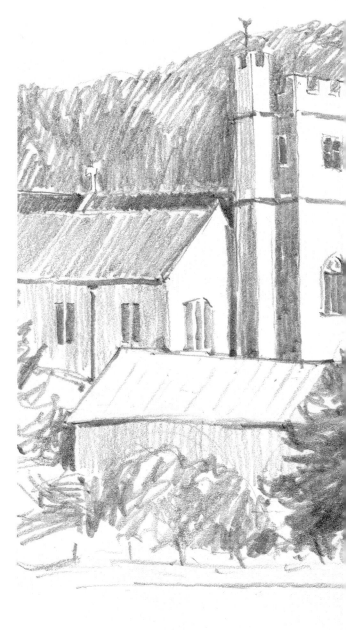

# DRAWING TIPS

- Don't be too neat and fussy with your pencil, or afraid of putting pencil lines on your paper

- Don't worry about rubbing out your pencil as you work. This is a natural part of drawing

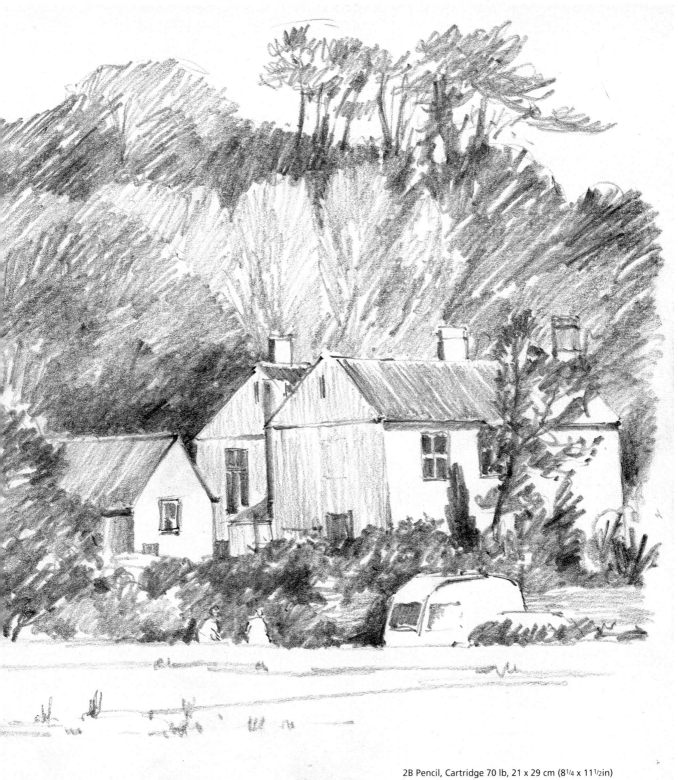

2B Pencil, Cartridge 70 lb, 21 x 29 cm (8¼ x 11½in)

# 6 SHALDON BEACH

## TONAL VALUES

If viewers thought I was squinting at Shaldon Beach, it wasn't because I needed to change my glasses – I was simply screwing up my eyes to assess the tonal values! This is the best way to see the real darks and lights that will help you show shape and form in a painting.

When I was a small boy at school, one of our jokes was to show a blank piece of paper to someone and ask them what it was. The answer was 'A white cat in a snowstorm'. Now, if you painted a white box on a white piece of paper, exactly the same would apply – it would be invisible. If you outlined it in pencil, it would have some shape but it still wouldn't look realistic. For that, it would need tone.

Up until now, I've only shown you washes representing flat areas of colour. But if you look around you, you will quickly see that every object is three-dimensional. To represent nature, it's important that you understand how to paint objects in this way. And, really, there is no mystery! It is simply by observing the light and shade – the tonal values – that you will be able to give form to whatever you paint.

In the figures opposite, I have painted the first box (Fig. A) all over with a wash of Hooker's Green No. 1. It has no form and it looks flat and unrealistic. In Fig. B, I have taken things a step further. When the first wash has dried, I've painted it with a second wash over two sides. In this way, I've 'turned the light on' and the box has started to take shape. In Fig. C, I've painted an

additional wash on the darkest side and now, as you can see, the box appears solid.

Objects can be seen because light falls on parts of them, forming shadows on other parts. Light against dark – dark against light. You can try experimenting with a table or desk lamp. Move it around to discover for yourself how some objects can be seen more easily when you change the position of the light source.

There is another way of bringing form and shape into your painting. This is by putting tone and shading with pencil into your drawing first, then painting a simple wash over the top. In Fig. D, I've done just that and you can see the colour I've used underneath the box. The paint on the box is just the same but it's gone over the tones that were already there and this makes the box look three-dimensional in colour. This method is useful if you don't want to mix a lot of complicated washes and it is called *pencil and wash*. I've used pencil and wash with the blue tube, too. There's no need to add any extra paint because the pencil shading is giving the tube form and shape, making it look three-dimensional.

Now it's your turn. Find some objects and look at them carefully for light and shade. Screw up your eyes and analyse their dark and light areas. Then practise painting them. I hope you will find this as exciting as I do – it's a wonderful feeling, creating the illusion of a three-dimensional object on a flat piece of paper! And remember, the first thing to do when you look at a subject is to screw up your eyes to see form and shape – that's dark against light and light against dark!

FIG. A *One wash of Hooker's Green No. 1*

FIG. B *A second wash over two sides 'turns on the light'*

FIG. C *An additional wash on the darkest side makes the box appear solid*

FIG. D *Pencil and wash*

47

# DRAWING BOATS

Students who don't like painting boats are usually people who can't draw them either! This makes sense because, if you aren't confident about drawing them on your paper, how can you possibly start to paint them accurately?

The answer is to get out and about with your sketch pad and have a go! It is only by practising that you will get over this barrier and really start to enjoy painting river and harbour scenes. To start with, only pick out one or two boats to draw at a time. Treat each boat as just another subject. Measure it to get the proportions right as you sketch it (see Programme 5) and don't forget to look at it with your eyes screwed up to see all the tonal values: light against dark, dark against light.

If you simplify boats in this way as you look at them (see my examples on these two pages), you will soon start to gain confidence. But it's no good trying it just once or twice – you must practise and practise! Then, once you are confident about drawing boats, you can start painting them in very simple washes.

*The shapes of the stern and propeller are easy to understand because they are dark against light*

*The boat looks three-dimensional because one side is dark and the other is light. Remember – light against dark, dark against light*

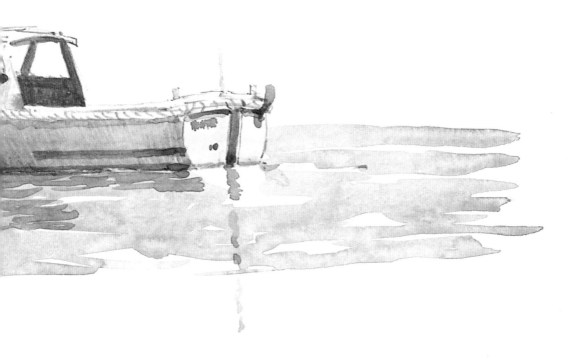

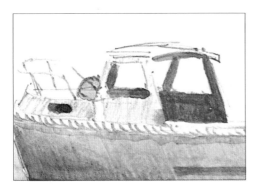

*Dark inside the cabin, light outside, gives a three-dimensional look*

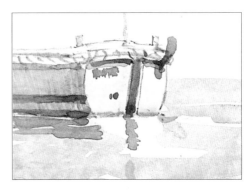

*Contrasting tones – dark against light stern, and light against darker water*

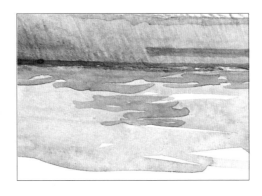

*The simple reflection is effective because it is darker than the surrounding water*

# 7 POLPERRO HARBOUR

## PEN AND WASH

You can never really rely on the British weather – it was such a wet and windy day at Polperro Harbour that I had to paint from the shelter of a fisherman's hut! But it's still one of my favourite programmes in the series.

Pen and wash is a very popular technique, so do have a go at it – drawing over the top of your painting with a pen can give a lovely sparkle to your work. You will need a 'dip-in-ink' pen with a drawing nib. Experiment with different nibs and don't be afraid of them; they are more flexible and stronger than you think. Just don't press too hard on upstrokes, which can damage the nib.

You will also need Indian waterproof ink. It is essential that your ink is waterproof or, when you paint over it, the ink will run and spoil your painting.

Finally, your paper. This should be harder and smoother than your normal watercolour paper, so that the pen will glide over the paper surface better. I've used Daler-Rowney Ivorex board, which is perfect for pen and wash.

Now to start practising! Hold your pen in a normal writing position and try some doodles to get used to it. You will find that if you press harder or work the pen sideways, you will get stronger, thicker strokes. Take the pressure off on upstrokes, or ink will splatter.

Pen and wash can be done in two different ways. You can draw your picture using waterproof ink, and then lay on washes over your pen work; or you can draw in pencil and paint your picture first, let it dry, then draw over the colours with your pen to give final definition and character.

When you use the pen and ink first, as I have done with the red boat opposite, you are more restricted – it's almost a case of colouring in your painting. I prefer the second method, which I used for my main painting of Polperro Harbour overleaf. When you apply the paint first, in this way, you can work wet-on-wet, using plenty of watery paint, which gives you much more freedom. You can let your colours run together as much as you like, because you will be drawing over the top of them with your pen, and this will hold the painting together. You will find examples of how I did this on pages 54 and 55.

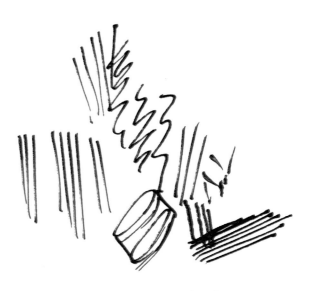

*Doodle to get used to the pen*

*Use very watery paint and let your colours run together. Always allow paint time to dry before working over it with a pen*

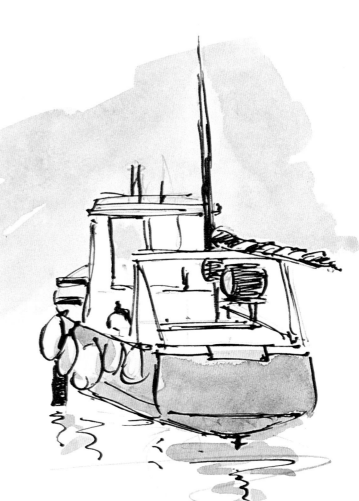

*You can draw in pen first if you like, then put colour over your pen drawing*

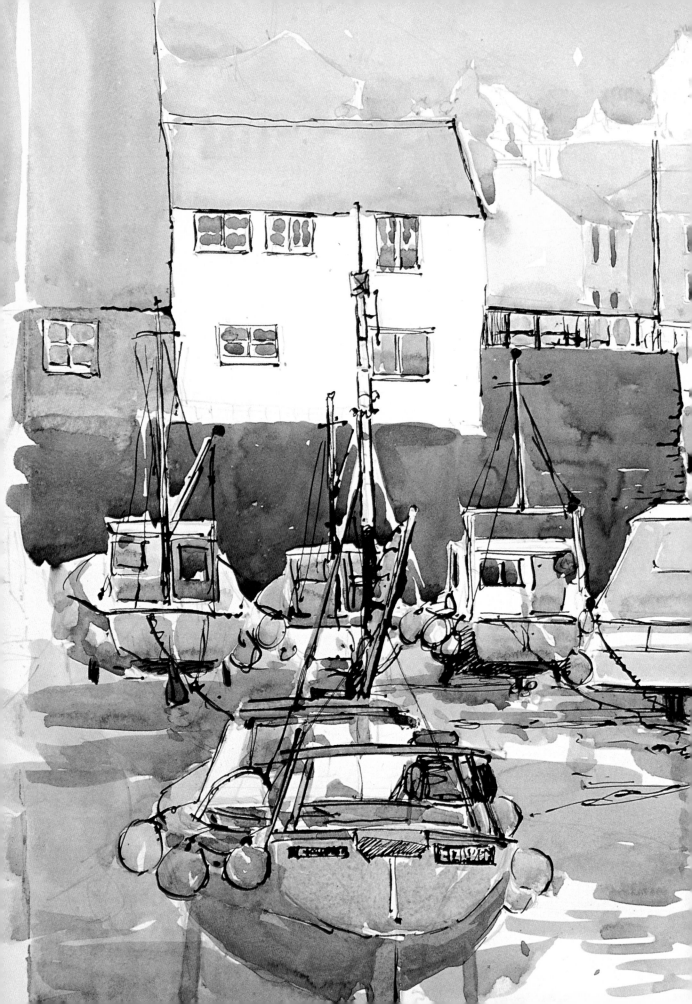

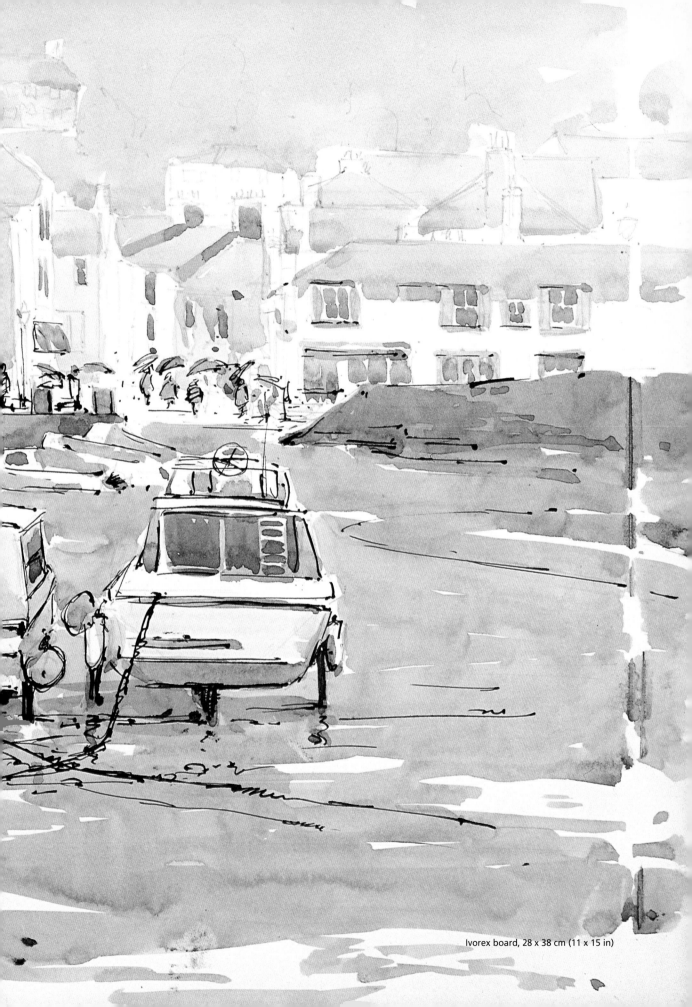

Ivorex board, 28 x 38 cm (11 x 15 in)

## DETAILS FROM THE PAINTING

*I didn't draw in ink over this area and this kept it soft and in the background*

*No paint was applied to the house – so it became the largest, whitest area in the painting, and the centre of interest*

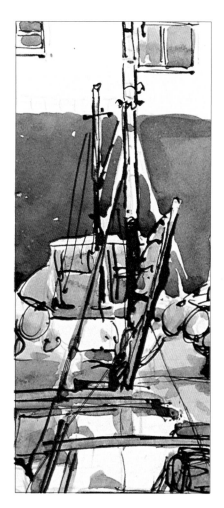

*My pen was let loose on these masts and the rigging! Here, I worked my pen sideways to get a thick line. The freedom with which this was done helped to give the impression I wanted*

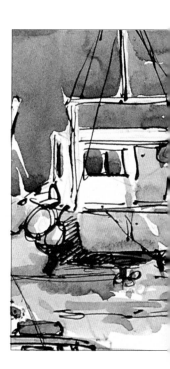

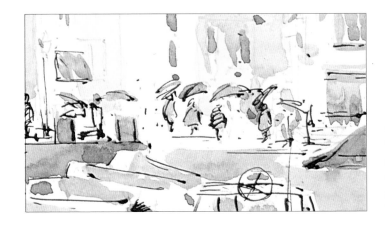

*I made sure I included the people holding umbrellas to show the atmosphere when I painted the picture – wet and windy!*

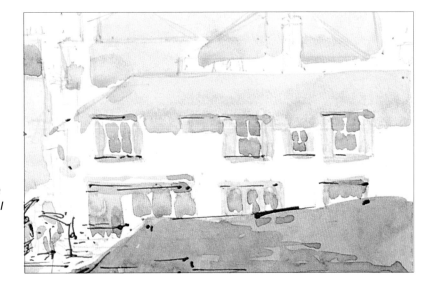

*The windows couldn't have been painted more simply. I used only a little pen work so they didn't become too important in the whole picture*

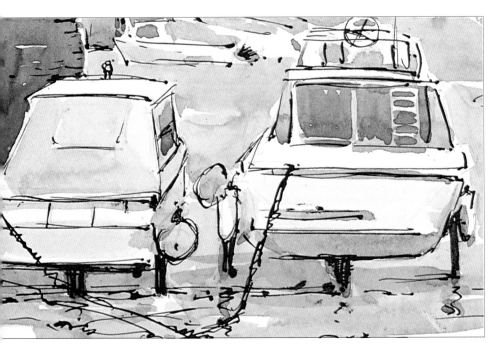

*There is very little detail worked either by paint or pen on the boats; I just picked out important shapes. But always remember – light against dark!*

# 8 STUDIO

## PAINTING FROM PHOTOGRAPHS

After being rained on in Polperro, I decided that – for this programme – I would take the easy way out and stay in my studio!

Of course, one of the biggest problems about working indoors is what do you paint? One way to get over this is to paint a picture from a photograph. You can see opposite how I did this for my book *The Half-Hour Painter*, using a photograph I had taken of the Eiffel Tower in Paris. The holiday photograph that I used was quite dark and without much detail, and so I used it only as a guide. A photograph should never be something to 'copy' from, or a short cut to learning to draw. You should always bring your own character into your painting – the photograph simply gives you somewhere to start your painting from.

However, painting from photographs is a good *exercise* because it will help to teach you the shape of things. A photograph of a tree, for instance, will show you how the branches grow outwards from its trunk, and how they get smaller all the way to the top. It can help with people and animals, too – on a photograph, they *will* stay still!

But, of course, you must also sketch and paint from life whenever possible, so that you get the real feel of things. There are details you cannot observe from just a photograph, although they can be a great source of inspiration for rainy days!

*The sky was done very freely to give movement. Notice that the Eiffel Tower was not worked in detail*

*I gave much more light to the distant buildings – this helped create distance. The figures were kept simple, but I did paint in their reflections*

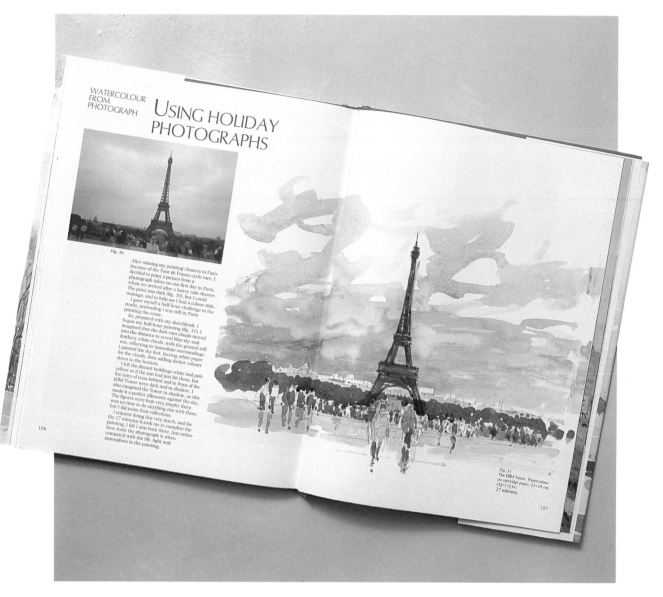

Inside the photographed book:

# USING HOLIDAY PHOTOGRAPHS

*Fig. 30*

After missing my painting chances in Paris because of the Tour de France cycle race, I decided to paint a picture from a photograph taken on our first day in Paris, when we arrived after a heavy rain shower. The print was dark (fig. 30), but I could manage, and to help me I had a colour slide. I gave myself a half-hour challenge in the studio, pretending I was still in Paris painting the scene.

So, prepared with my sketchbook, I began my half-hour painting (fig. 31). I imagined that the dark rain clouds moved into the distance to reveal blue sky and feathery white clouds, with the ground still wet, reflecting its immediate surroundings. I painted the sky first, leaving white paper for the clouds, then adding darker colours down to the horizon.

I left the distant buildings white and pale yellow as if the sun had just hit them, but the rows of trees behind and in front of the Eiffel Tower were dark and in shadow. I also imagined the Tower in shadow, as this made it a perfect silhouette against the sky. The figures were kept very simple; there was no time to do anything else with them, but I did paint their reflections.

I enjoyed doing this very much, and for the 27 minutes it took me to complete the painting, I felt I was back there. Just notice how static the photograph is when compared with the life, light and atmosphere in the painting.

106

*Fig. 31
The Eiffel Tower. Watercolour on cartridge paper, 21×29 cm (8¼×11 in)
27 minutes*

107

---

## STILL LIFE

Still life is something that is traditionally done indoors, and it is one of the best ways to learn to paint because you can control both the subject and your working conditions. Still life means that the object or objects to be painted are inanimate and therefore do not move. It's worth bearing in mind, though, that flowers and fruit can change in appearance, depending on how long it takes you to finish your painting!

Before you start, here are some important points. Don't be too ambitious to start with. Set up just a few objects that have simple shapes and colours, and then put them on a contrasting background. Choose where you set up carefully. You'll run into trouble if someone wants to use the table and you have to move your still life before you've finished your painting. (Also make sure that none of the objects you're using will be needed by someone else in the near future!)

One of the most important things about still life is your light source. The best light source is an adjustable desk lamp which can be directed on to your subject to give maximum light and shadow – *dark against light*. For the still life painting on the next pages, I adjusted my light source to cast an interestingly tall, dark shadow behind the teapot.

Setting up a still life can be very absorbing, as you are using your creative skills. But don't forget the object of the exercise – and spend so long creating the scene that there's no time left to paint it! You will find some examples of how I painted my *Still Life with Teapot* overleaf.

57

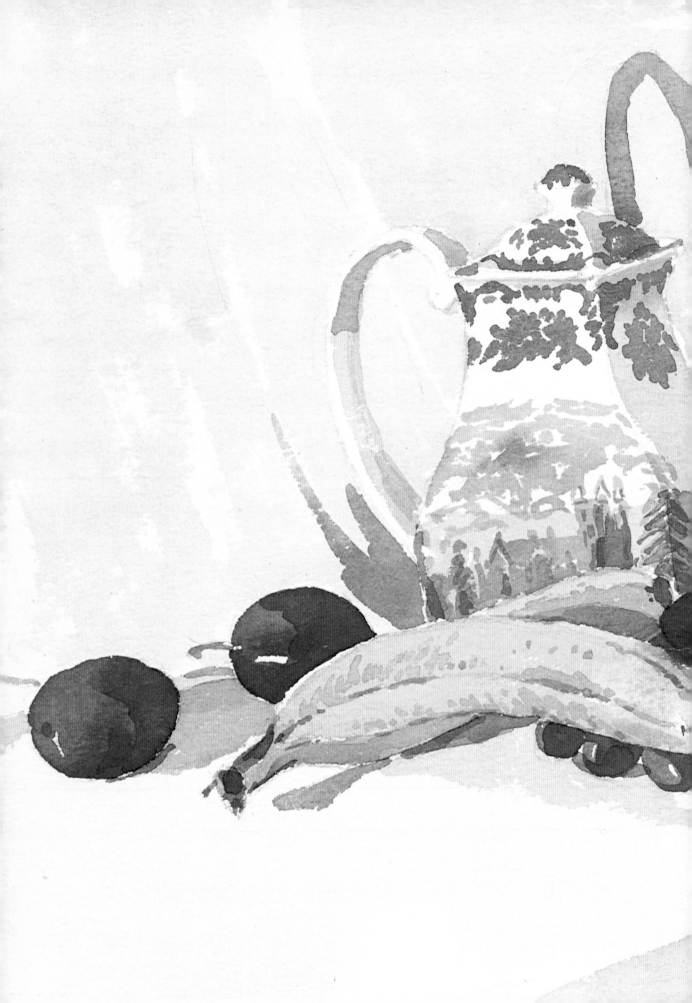

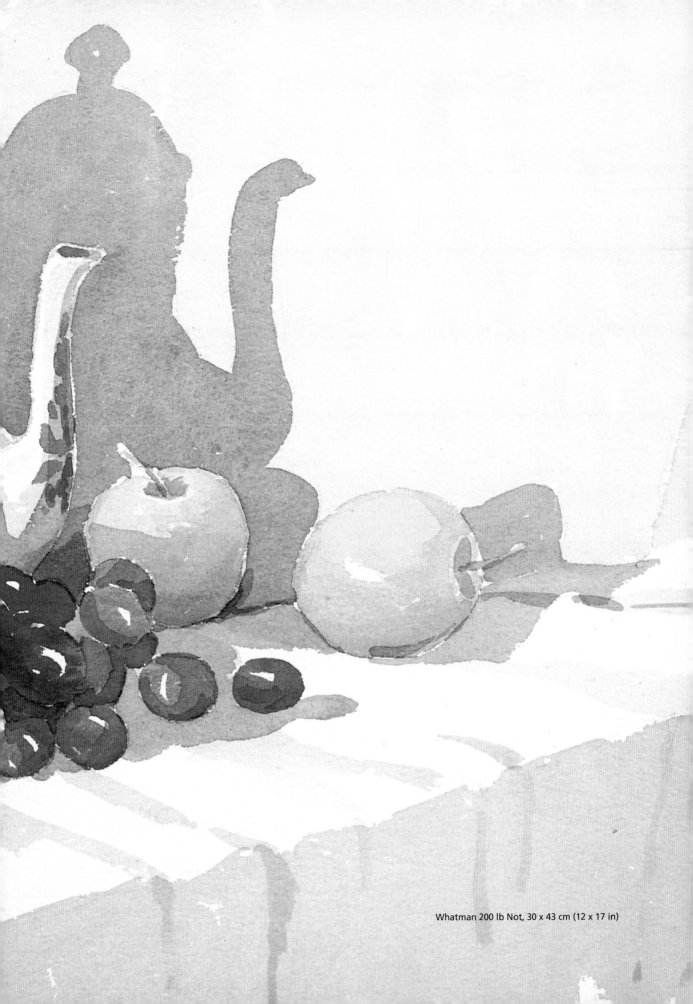

Whatman 200 lb Not, 30 x 43 cm (12 x 17 in)

*The blue colour from the grapes ran into the yellow paint of the banana while it was still wet. This hasn't spoilt the painting. On the contrary, it has helped the banana and given it a reflected colour from its surroundings. Notice how I haven't overworked the brown spots or marks on the banana*

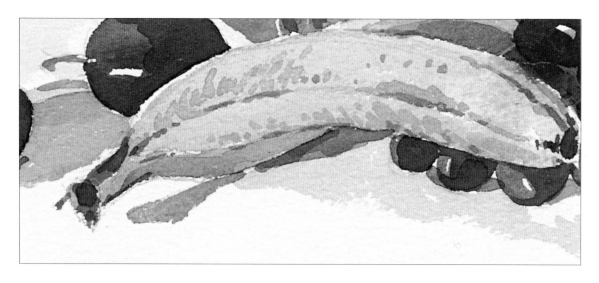

*I left the white paper unpainted for the highlights on the grapes – these should follow the natural curve of the fruit*

*The pattern of the teapot was kept simple. I used brush stroke K (page 28) and my No. 6 brush to keep the pattern flowing*

*Shadow must be painted in one continuous wash – don't be tempted to fiddle! Notice how free mine is, especially the edges*

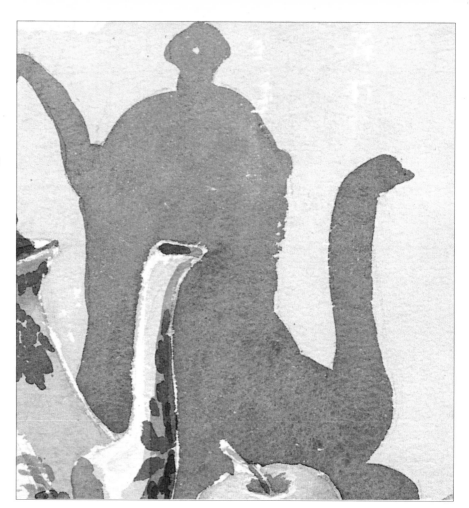

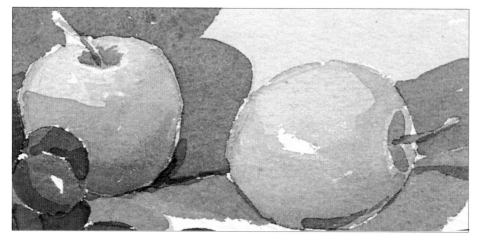

*The apples and plums were painted in very simple washes, again leaving white paper unpainted for strong highlights*

# 9 EXETER QUAY

## PAINTING TREES

Exeter Quay presented me with an excellent opportunity to paint two of my favourite watercolour subjects: trees and water. I love painting trees but I know they worry a lot of people, so let's have a look at how to paint them simply. I've shown you how to paint them in the middle distance, not close up. Like all subjects, you must observe them carefully in order to draw and simplify them.

One golden rule to follow when you are drawing or painting trees without leaves (see Fig. A) is to always work from the bottom of the tree upwards and outwards in the natural direction that the branches grow. Branches get thinner as they reach the top, so never start at the top of a branch and work downwards. A natural brush stroke starts thick (because a full brush puts most paint on to the paper and you use most pressure when you first apply the brush). As you finish the stroke, it gets thinner, particularly as you start to relax pressure just before you lift the brush off the paper.

When you are painting trees in leaf (see Fig. B), let your brush strokes follow the fall of the leaves. Don't try to copy every branch or leaf – it's impossible – aim for a feeling of character and shape. It's the overall impression of the tree that you are trying to achieve.

Fig. A

Fig. B

# PAINTING WATER

Although it may seem a bit daunting at first, the illusion of water can be created quite simply in watercolour painting. It's really not so much a case of what you put in, as what you leave out! Keep things simple, otherwise water can look unnatural.

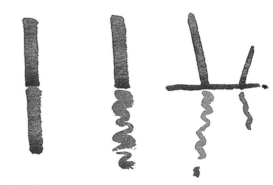

In Fig. C, an illusion of water has been created by leaving the paper white. The secret ingredient is the use of reflections. If a painting has a reflection in the water, it will give the impression of water. Look at the first post in the picture. The reflection is a copy of it and this is the simplest way to show still water. But if you look at the second post, the reflection shows movement, because I've broken the vertical reflection to create the effect of light and movement of the water. The two posts on the right are both at an angle, and their reflections are painted at the opposite angle to each post, a rule which applies to all reflections.

Fig. C

Of course, if water is painted blue, it looks even more realistic. The yacht (Fig. D) is simply a white silhouette on a blue background with a white reflection, but immediately the reflection tells us the blue is water.

When painting water, use a very wet-on-wet technique and *bags of water*. This is something worth practising your washes for! And don't forget your dry brush technique, either. It will allow areas of paper to be left unpainted, giving a look of sparkling sunlight on the water.

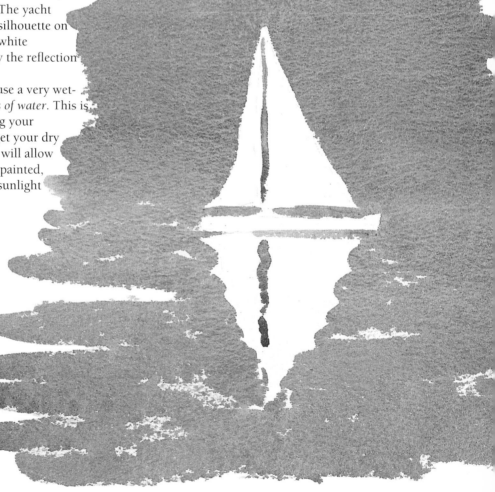

Fig. D

## PAINTING EXETER QUAY

When I first saw this scene with the tall poplar tree, the house at its side and the gorgeous reflection made by the tree in the water, I couldn't wait to start painting! Sadly, when I revisited Exeter Quay recently, the white building was being renovated and it is now all red brick! So, if you see something you like, do paint it as soon as you can.

But let's get back to my painting. I put the sky in first as usual and, when it was dry, I painted in the main group of trees. Notice how the poplar tree is the darkest 'dark' on the painting and it is next to the lightest 'light' – the white house. This makes a very powerful focal point.

When I came to paint the reflections in the water, they no longer showed. Reflections are funny things and seem to defy all logic. Sometimes they're there in all their glory, other times there isn't a reflection to be seen. And sometimes they even seem too long or too short for the object they are reflecting! The simple answer to reflections is to spend time observing them. You will gradually get a feel for the way they reflect in water. Then, if you have a 'poor' reflection in your scene when you are out painting, you will have the experience to alter it, to help your picture.

Notice how simply I painted the reflections in this scene. When the first wash on the water was dry, I painted in the reflections over the top. You'll see that I left the house reflection unpainted, except for the two windows. You need confidence to do something like this, so keep practising those reflections.

## PAINTING TIPS

- If water is moving, don't let your eyes follow the movement, keep looking at one spot to pick out the reflected shapes

- Half close your eyes to help you see the patterns formed in the water by reflections of the surroundings

- When painting water, strokes must be level, otherwise water will be running downhill

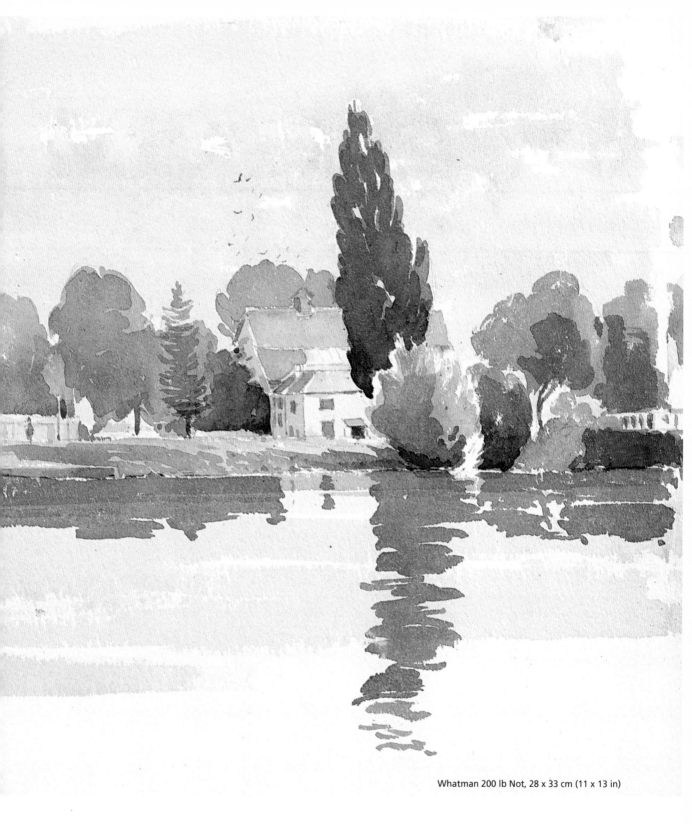

Whatman 200 lb Not, 28 x 33 cm (11 x 13 in)

# 10 PAIGNTON ZOO

What better place than the zoo to draw and paint animals? It can make a perfect day out if the weather is good – and for another reason, too. Since there's usually a crowd, it's also a useful place to practise painting people. So, before we turn to animals, I'm going to teach you a little more on this subject.

## PAINTING PEOPLE

On the opposite page, I've shown you some very easy ways to paint figures, which can be used in any simply worked watercolour painting. Remember, the further away people appear in a painting, the less detailed the figures should be. My examples are really just impressions of people in the middle distance, worked with just a few simple brush strokes, but these can be very effective even as the centre of interest in a painting or as part of the scene.

Start by mixing a flesh colour with your paint (Cadmium Red and a touch of Cadmium Yellow Pale) and paint a head. This is basically one brush stroke and, when painting people's heads, they should be oval, not round. Hair is another simple brush stroke but this should be carefully applied because it will indicate which way the head is pointing. With the three heads I've painted, the first is facing us, the second has its back to us and the third is looking to its right. Straightaway simple 'blobs' have become more lifelike.

When painting figures, use your flesh-coloured paint again. First paint the head, then the body, arms and legs. This should be done in one movement in a few seconds, so don't be tempted to fiddle. It sounds fairly easy and it is, but you will need lots of practice. When the paint is dry, you can add clothes, but remember to keep things simple at first. As your confidence grows you will be able to put more modelling into your figures. This type of figure painting is great fun and with practice you will find that, with simple brush strokes, you can portray very convincing movement and character.

Next, I've used the same principle to paint figures in silhouette, dark against light. But don't make the mistake of adding feet! I've shown you in my last silhouette the unnatural 'Charlie Chaplin' effect you can get if you do this.

You can also work the opposite to the silhouette effect, using light against dark – see my example of a crowd scene which is painted against a dark background. Paint the background first, leaving shapes of figures unpainted. When the background is dry, add colour to the figures, leaving some unpainted white paper.

*Front*  *Back*  *Looking right*

*Keep your figures very simple – don't try to put detail in their clothes*

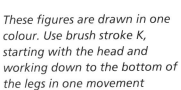

*These figures are drawn in one colour. Use brush stroke K, starting with the head and working down to the bottom of the legs in one movement*

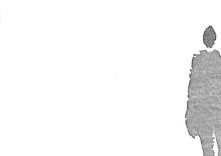

*Unless a figure is close up and large in your painting, don't put feet on it*

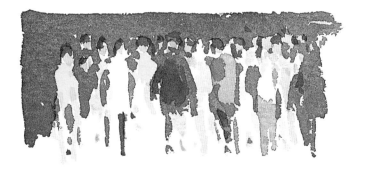

*You can paint people using light against dark, too – as with this crowd scene*

# DRAWING ANIMALS

When learning to paint people, you do have a distinct advantage – you can sometimes ask them to stand still and *pose* for you! That isn't the case with animals and this is one of the real problems when drawing or painting them. But do try to draw and paint animals from life whenever possible because you won't get a real feel for the fur, colour or the way they move from just looking at photographs.

Start by going out with your cartridge paper and a 2B pencil to sketch, observe and learn. Always be patient with yourself. It can take 15-20 minutes to get your brain and pencil working together to achieve any good drawings and become accustomed to the speed at which you have to work. Of course, it is disappointing to get halfway through a good sketch when the animal decides to move off, but inevitably this *will* happen! Just let it be your *cue* to start another sketch. Remember that the object is to learn, not to produce a single, perfect drawing. Animals can be fascinating subjects and, once you feel confident about drawing them, it will give you the confidence to start painting them, too.

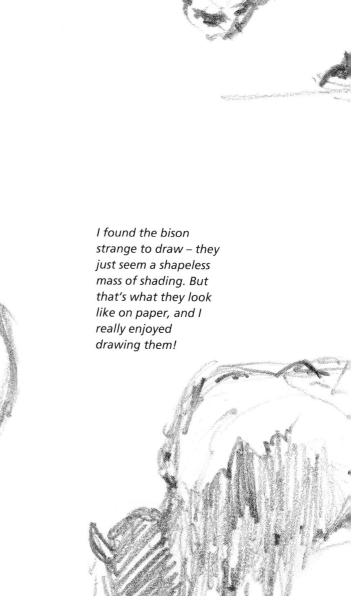

*I found the bison strange to draw – they just seem a shapeless mass of shading. But that's what they look like on paper, and I really enjoyed drawing them!*

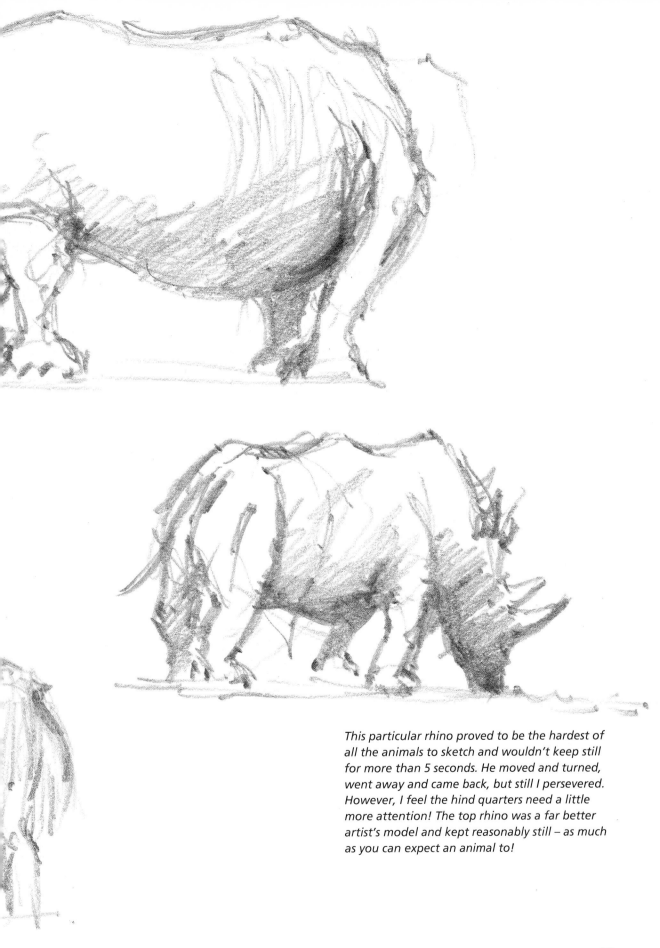

This particular rhino proved to be the hardest of all the animals to sketch and wouldn't keep still for more than 5 seconds. He moved and turned, went away and came back, but still I persevered. However, I feel the hind quarters need a little more attention! The top rhino was a far better artist's model and kept reasonably still – as much as you can expect an animal to!

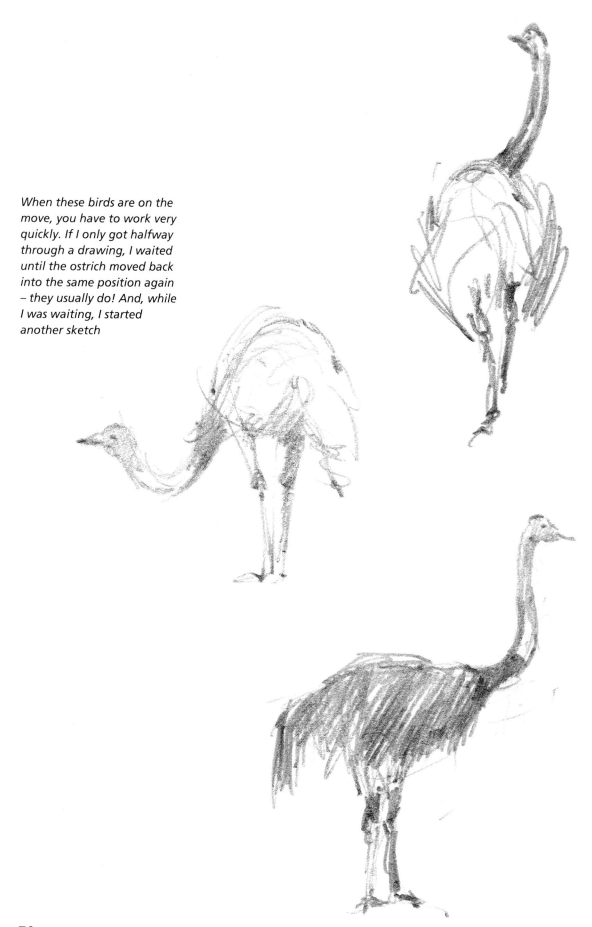

*When these birds are on the move, you have to work very quickly. If I only got halfway through a drawing, I waited until the ostrich moved back into the same position again – they usually do! And, while I was waiting, I started another sketch*

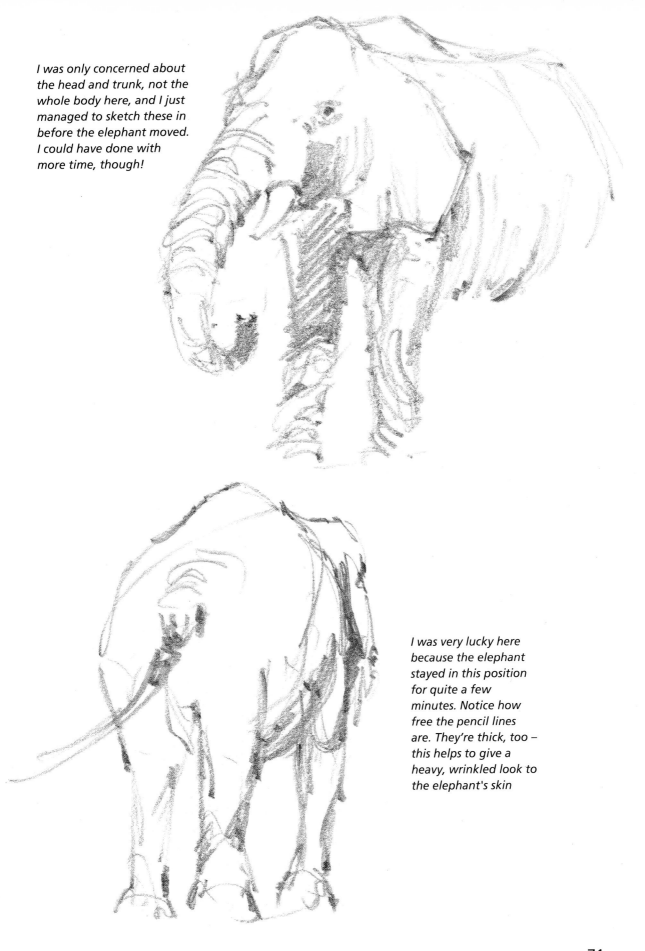

*I was only concerned about the head and trunk, not the whole body here, and I just managed to sketch these in before the elephant moved. I could have done with more time, though!*

*I was very lucky here because the elephant stayed in this position for quite a few minutes. Notice how free the pencil lines are. They're thick, too – this helps to give a heavy, wrinkled look to the elephant's skin*

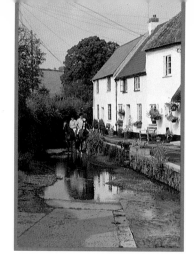

# 11 COTTAGES, IDE

These Devon cottages are gorgeous, and they've even got a river running down the side! It's a lovely scene but when you paint this type of picture, it's important to be careful not to go over the top. If you put too much detail into your painting, your finished work will look contrived and, if anything, too pretty and like an illustration for a chocolate box. You can see my painting of these cottages overleaf, but first I'm going to talk about two things that can worry beginners to watercolour painting – windows and skies.

## PAINTING WINDOWS

On the opposite page, I've painted some examples of windows. You'll see I've kept things very simple – these are windows that are viewed from a distance, not close up. The first (top left) has two windows, one with a window frame and one without.

The example below this is an easy way of painting windows on the side of the building, using simple brush strokes to fill in the shape of the window panes.

The bottom window and the large one (far right) have more character and modelling because I've painted reflections in the glass and put more detail into the window frames. But still, you'll see, I've kept things simple – and this is what you should do. When you are painting a building, look at the windows and screw up your eyes to show you the shapes and forms. Then paint in the shapes that you see but, remember, always *simplify* them!

## PAINTING SKIES

If you work too *dry*, you will have problems painting skies. The people who are 'naturals' at painting skies are the ones who are not worried about mixing paint with plenty of water! They slop it on (but in a controlled way) and the colours mould beautifully into sky and clouds. When you work the colour in, don't paint in any detail but aim for an overall effect of the sky. You will be working fast and colours will run into each other, but this is what you want. The more you practise, the more you will be able to control the way the colours mix on your paper.

In the example at the bottom of the opposite page, the sky was created by applying only two washes of colour. Start with skies which can be painted very simply – you can progress and add more detail and character as you gain experience.

*Use simple brush strokes for each window (brush stroke E)*

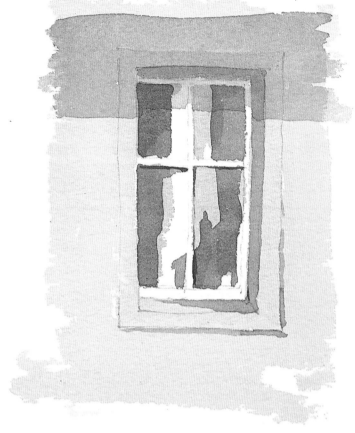

*These are done in the same way as the ones above. When the first wash is dry, a second darker wash is painted over it to give more modelling to the glass*

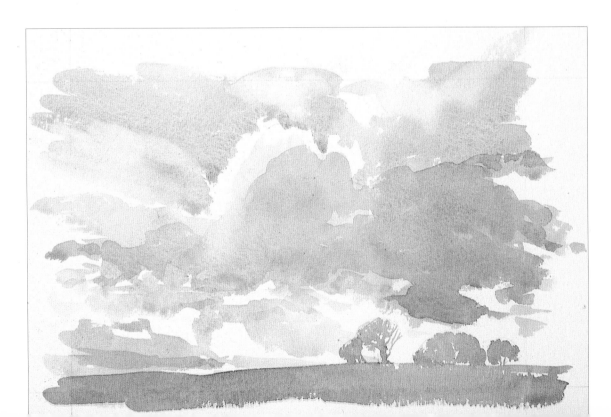

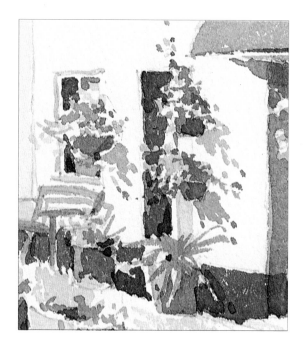

*Don't try to paint individual flowers – give the impression of flowers by letting your No. 6 brush 'blob' the colour on. Shadows play a very important part here, helping the baskets appear three-dimensional*

Whatman 200 lb Not, 21 x 29 cm ( 8¼ x11½ in)

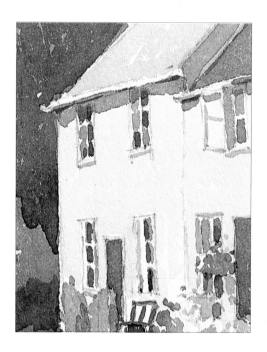

*All the windows are done in a very simple wash (see previous page) and yet they look correct in the painting as a whole*

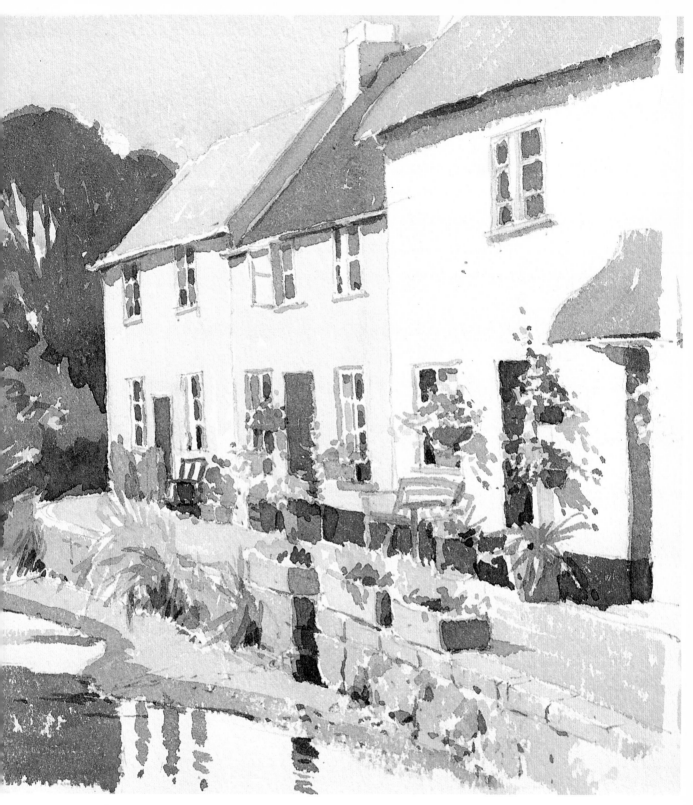

*A dry brush technique (see page 26) was used here – notice how it gives the illusion of ripples on the water*

# 12 BRIXHAM HARBOUR

## PAINTING A COMPLEX SCENE

Brixham is a lovely, busy harbour – there is always a wonderful array of subjects to choose from in this sort of location. It was a complicated scene and this gave me a perfect opportunity to demonstrate what can happen when all the different techniques that we've dealt with in the previous 11 programmes are brought together in one painting.

I hope that I have removed some of the mystery from watercolour painting and given you enough information to encourage and inspire you to have a go for yourself. Practise and it will give you confidence – the more confident you are, the better your watercolour painting will become, and the more you will enjoy it. You now know about materials, choosing a view, measuring, brush strokes and painting washes. You know how to look for tonal value, to screw up your eyes to see dark against light and light against dark. You also know how to paint people, windows, skies and so on – but, most importantly, how to simplify what you're seeing. I've shown you my way of working, but do try to let your own style develop. In time, your way of working will be different to mine, and that's fine.

Now's your chance to put all these skills into practice. Always remember the golden rule of watercolour painting – *bags of water*! Do have a go – watercolour painting is tremendous fun, and easier than you think!

*The people have been done with simple brush strokes (see Programme 10)*

*Tonal values give form and shape to objects, as with these windows and the statue – dark against light and light against dark (see Programme 6)*

*This area was built up using simple washes (see Programme 2)*

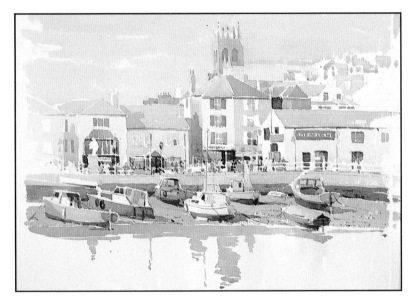

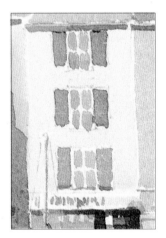

*These windows have been simplified so they don't 'jump out' of the painting (see Programme 11)*

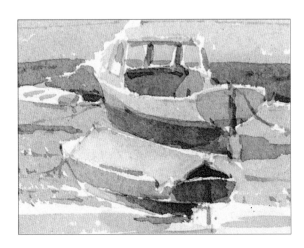

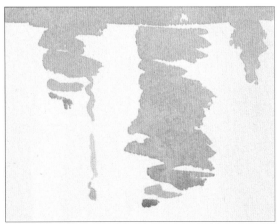

*You can see the importance of tonal values with boats but it is also important to get their proportions right by measuring (see Programme 5)*

*Simple reflections are very effective (see Programme 9)*

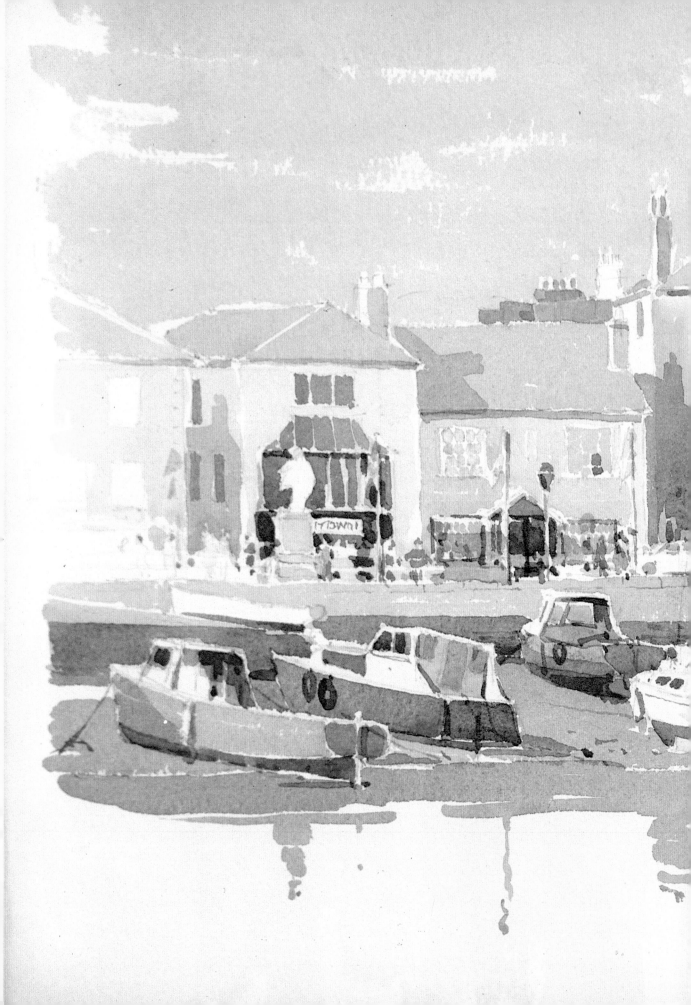

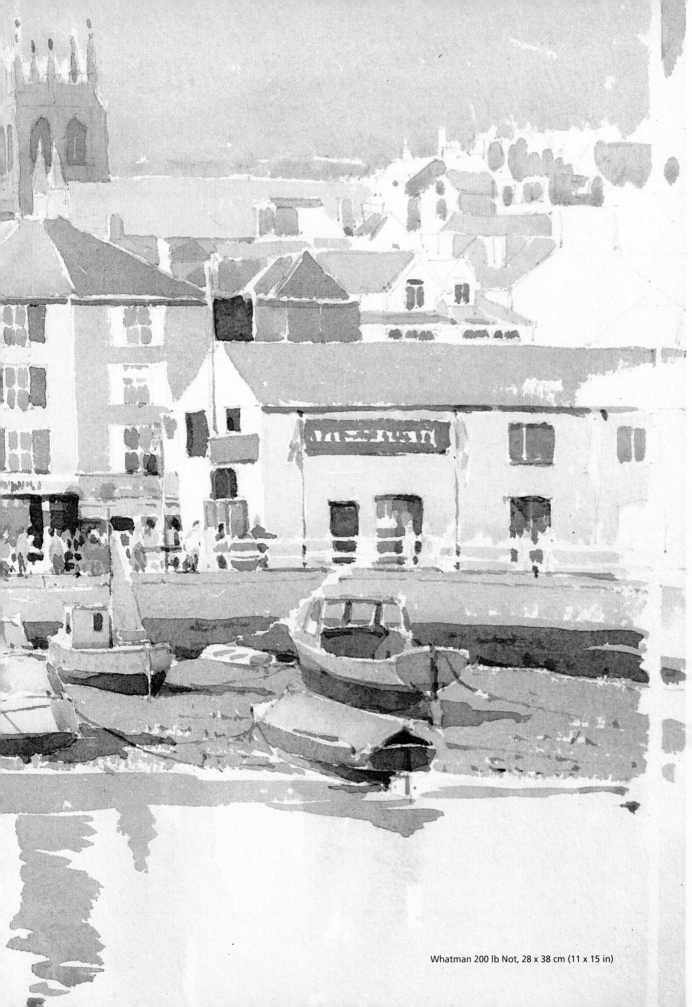

Whatman 200 lb Not, 28 x 38 cm (11 x 15 in)

# A Brush with Filming

Behind the scenes on location with *A Brush with Art*

***Eyes in my toes would be an asset! Hound Tor***

Some of you will be familiar with the term 'outtakes' – it describes all the shots in a film that are not used, or are edited out of the final version. There are many reasons for outtakes to happen – it could be that someone forgot their lines, an unwitting member of the public crossed in front of the camera, or a jet plane flew overhead. Sometimes the same scene has to be shot time and time again.

This was the first time I'd had my own television series, and making 12 programmes on location is really going in at the deep end! Although I'd appeared on television before, I soon found that there were two major problems I had to overcome. The first was to be able to walk on camera to a designated spot where a marker had been placed on the ground, and then turn to camera and deliver my words, right on cue. Believe me, this isn't an easy thing to do when

you're supposed to be looking around you at the view in order to pick a suitable spot for painting, and therefore you can't look at the ground – let alone your marker!

My first experience of having to do this was in Programme 3 when we filmed at Hound Tor on Dartmoor. I had been given my route and we did the first take, but I was too far away from the camera when I stopped and turned around – so, sorry Alwyn, take 2! On the next take, more by luck than judgement, I found the correct spot and started to deliver my lines, only to be upstaged by a low-flying helicopter. For take 3, the crew let me into a 'trade

*Before the crowds set in.* **Dawlish Warren Beach**

secret'. If I counted my steps first, then all I had to do when being filmed was to count them again and I would be in the correct spot. It sounded easy, and take 3 commenced. I started to count, got to 12, turned to the camera and – hey presto – there I was, in the right place. But at this point, Ingrid, our director, called "Perfect, Alwyn – but please don't count the steps under your breath, because we can hear them on the recording!" Well, luckily, take 4 was fine – and about time! After all, now I had some painting to do.

The second problem,

*More thinking time.*
**Hound Tor**

of course, was the actual painting. If you have ever used watercolour, you will know that it is a medium that can have a will of its own. To paint successfully in watercolour, the artist needs to have as much control over the medium as possible. That's fine under normal painting circumstances but, with all the inevitable stoppages during filming and the somewhat erratic behaviour of watercolour, I'm both surprised and delighted that we all managed to make the series work so well.

I must confess that I did start to feel a little harassed on Dawlish Warren Beach (Programme 4). It's one thing painting watercolour, it's quite another trying to concentrate while you're being filmed painting it, and so much *else* is going on! That day, there were hordes of people on the sun-soaked beach and there were children and teenagers enjoying themselves within easy reach of our microphones. That is fine for atmospheric background sound but, of course, I had to be heard above everything else. Graham, our sound engineer, did a great job to overcome all this, but there were quite a few occasions when I had to

81

*Can I sit down now? Harpford*

stop painting because people were enjoying themselves a little too close to our camp! It was also fairly difficult to concentrate on what I was saying to the camera at times – especially when two boisterous teenagers sent sand flying all over my paintbox.

During the making of the series, my wife June was the only other artist in the group and, as always, her help was invaluable. Because of all the other things my brain had to cope with while filming, June watched me as I painted and, at break times, we would have a discussion about how the particular painting was progressing. June was always able to offer constructive advice and remind me of various points I hadn't made which, as another artist, were obvious to her.

*Be fair, that was a bit of a tongue-twister! Harpford*

82

Even in summer, the weather in Britain is a gamble. When we filmed in Polperro for Programme 7, the weather was terrible. Rain was coming down so hard, it was

*No, sorry – you can't paint that old boat, Alwyn!* **Exeter Quay**

bouncing three or four inches off the road outside our hotel, and the clouds were so low, they were practically bouncing off the road as well! Since this programme was specifically designed to demonstrate painting sunlight and shadows, the situation called for some quick rethinking! Eventually, a solution was found – we were to use a fisherman's hut that the harbour master would make available to us. The programme was quickly rewritten in the hut, while drying clothes, setting up cameras and microphones, etc., and the programme was opened by me stating the facts, plainly and with nothing acted – that I'd expected the sun in Polperro, but just look at the rain! Needless to say, we got through it all and finished the programme. Everyone worked very hard and got very wet, but this particular programme is now one of my firm favourites!

*Shelter from the storm.* **Polperro**

The previous programme, which was shot at Shaldon Beach, had its moments, too. We were going to film on the beach and I was to paint a view at the end of the town with the houses along the river estuary. This programme was to be about light and shade and it was a glorious summer morning when we arrived and made our camp on the lovely soft sand. I got myself positioned for the painting and waited for the crew to get their equipment set up. Fifteen minutes later, a group of holidaymakers sat down on the beach near us

83

*The first hint of the mist.* **Shaldon Beach**

and erected a large windbreak – although there wasn't a breath of wind! From where I was sitting, the windbreak cut out my view completely. David, the producer, was about to go and ask them if they would move it, when the windbreak – and the view – almost disappeared. It was sea mist and it looked if it was there for the duration, so back to the drawing board! I decided to make the programme about working dark against light and light against dark, one of the most important lessons for painting and drawing. Luckily, I found some interesting boats to paint, which were moored nearby in case the mist got any thicker.

So, all the equipment was moved to another part of the beach and, with yet another late start, this programme was made. You certainly have to be adaptable when out filming – or painting – in the British climate!

Because we were filming in the West Country, Ingrid and David had their hearts set on one painting showing some typical Devon cottages. I was rather against this idea because, in a painting, such cottages can look a bit *too* pretty, and it's not the sort of painting I would usually do. However, I soon realised that I was fighting a losing battle and so, on a bright, sunny but cold day, I started Programme 11 in a little village called Ide, near

Exeter. I must admit that I wasn't feeling very inspired that morning, but I decided to stop thinking negatively, called on all my professional experience and started with a blank piece of paper with the cameras turning. To start with I found drawing under camera a little nerve-wracking, as there is not much licence for an incorrect line with this type of subject. If you are drawing trees, for instance, and you draw a branch too high or too low, it still looks like a tree, but you can't reposition a doorway or window without it being noticed! However, after a while I became really absorbed in the work and when I had finished the drawing I was very pleased with it. In fact, in the end, I was pleased with the painting, too. I enjoyed doing it, especially the sequence in the film where I am painting the baskets of flowers on the cottage walls. So I'm actually glad I lost that

*...nearly finished!* **Brixham Harbour**

*The start of a long day – and a feeling of being wanted.* **Brixham Harbour**

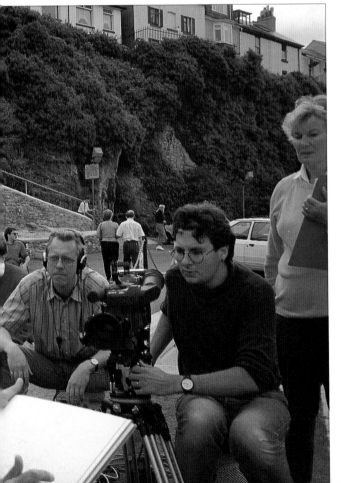

battle over the Devon cottages, because this turned out to be one of my favourite programmes in the series, too!

When I did the big painting of Brixham Harbour for Programme 12, I think the cameramen deserved a medal. It was a complicated painting and it took four hours to film altogether. This naturally included breaks for paint to dry, camera batteries to be changed, and so on. When doing such long filming, nerves can get frayed and tempers can run high, but it's a team effort and everyone gives that little bit extra. And, of course, we did have a terrific team! So, as with the rest of the series, at the end of the day (outtakes excluded!) Brixham Harbour was 'all right on the night' and I was very happy with it.

I hope this insight into making the television series will entertain you when you are looking at or working from this book. I hope too that it will inspire you to go out and find some interesting locations to paint yourself. Of course, if it helps you to learn, you can copy any of the paintings in this book, but don't try to copy them *too* exactly, or you will find that your paintings will look tight and unspontaneous. If the colours aren't quite the same, or the composition varies a little – so much the better. Even I would have a job to exactly copy my own work!

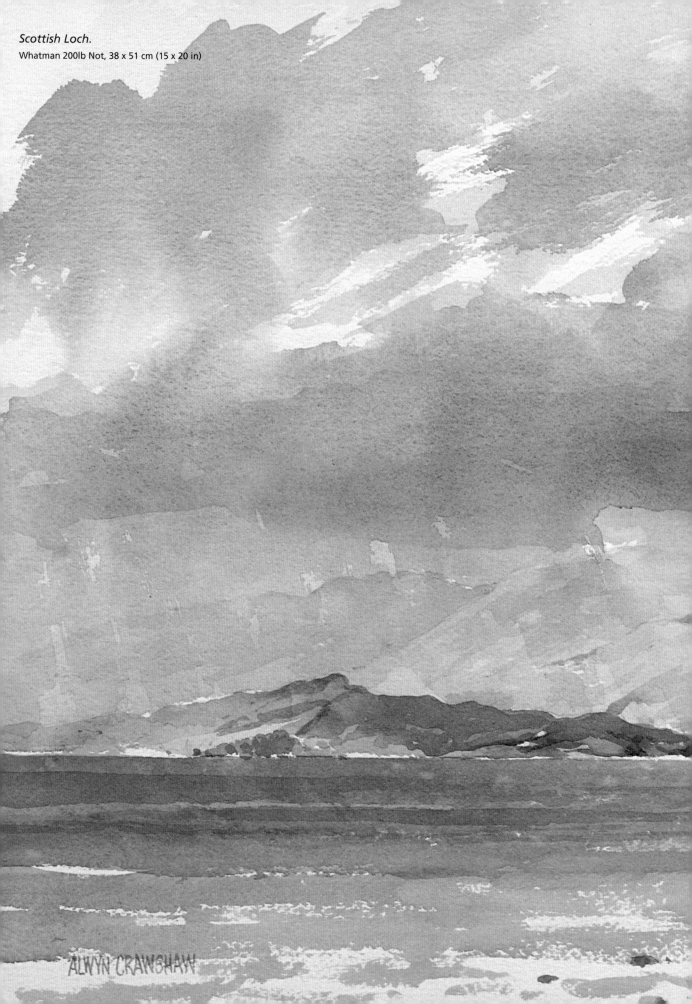

*Scottish Loch.*
Whatman 200lb Not, 38 x 51 cm (15 x 20 in)

ALWYN CRAWSHAW

# GALLERY

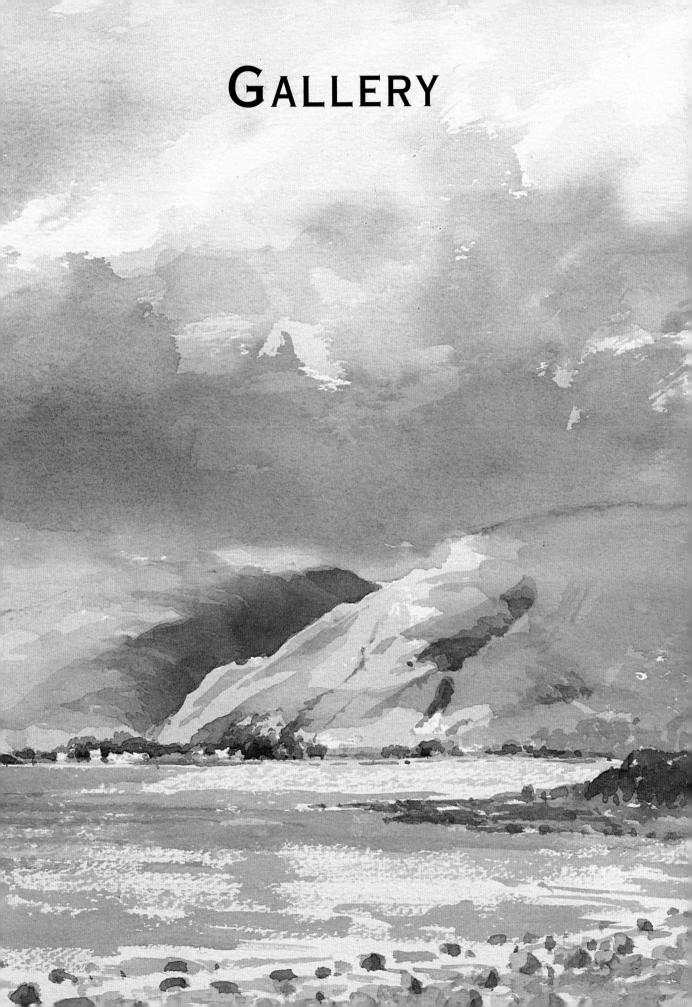

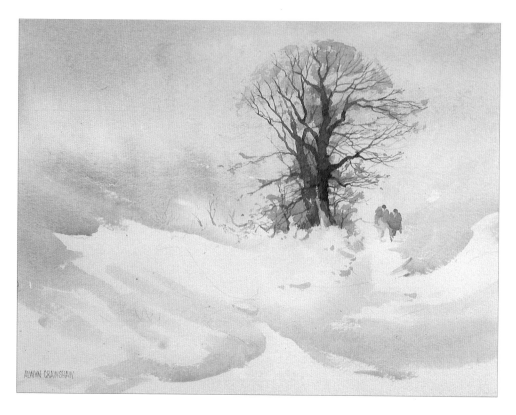

ABOVE: *I shall be glad when we move to Somerset!*
Whatman 200lb Not, 38 x 51 cm (15 x 20 in)

BELOW: *Autumn, Harpford.*
Whatman 200 lb Rough, 38 x 51 cm (15 x 20 in)

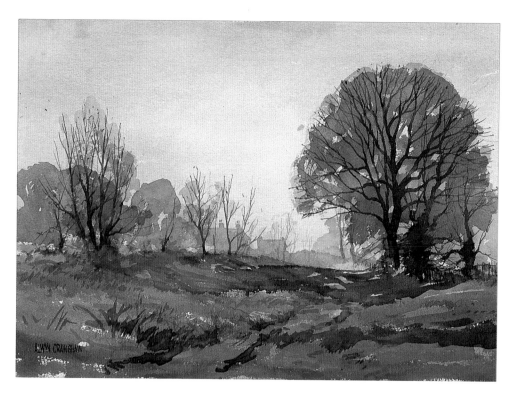

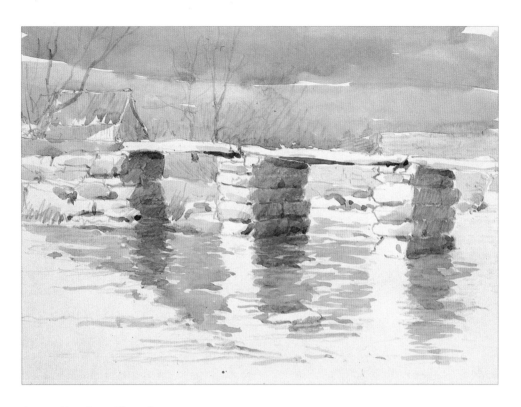

ABOVE: *East Dart River, Devon.*
Cartridge paper, 20 x 28 cm (8 x 11 in)

BELOW: *Polperro Harbour, Cornwall.*
Whatman 200 lb Rough, 38 x 51 cm (15 x 20 in)

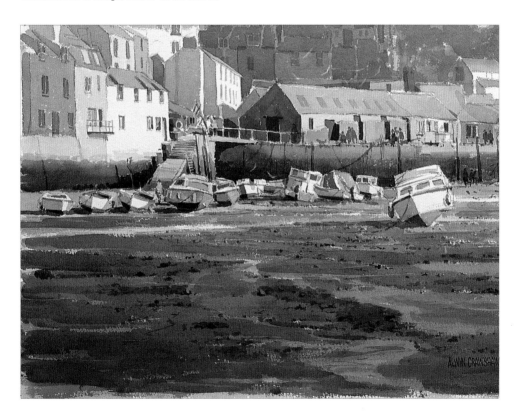

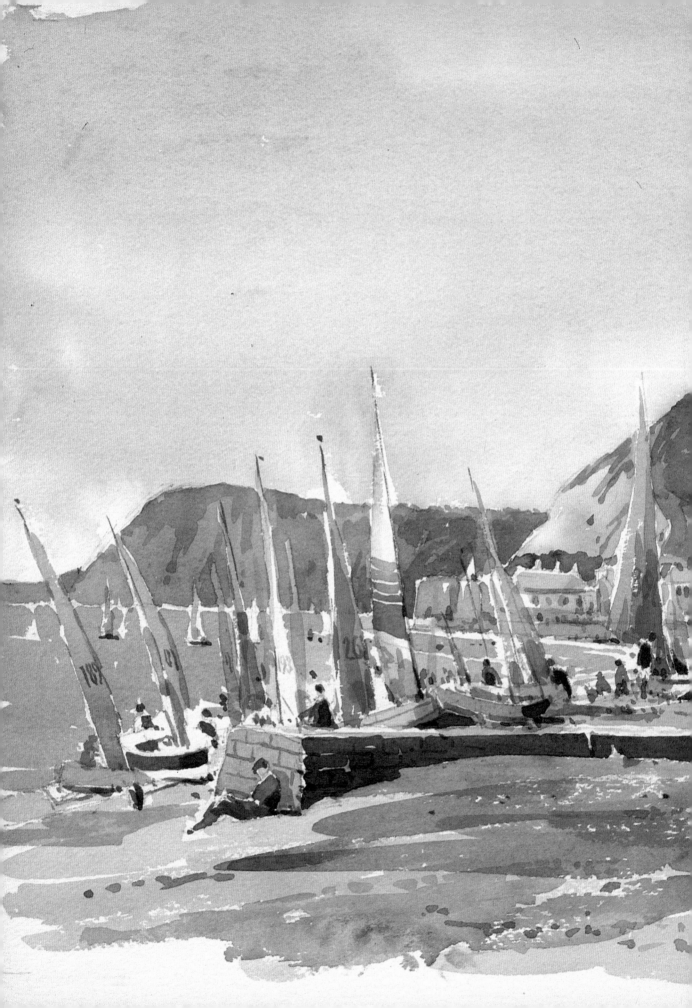

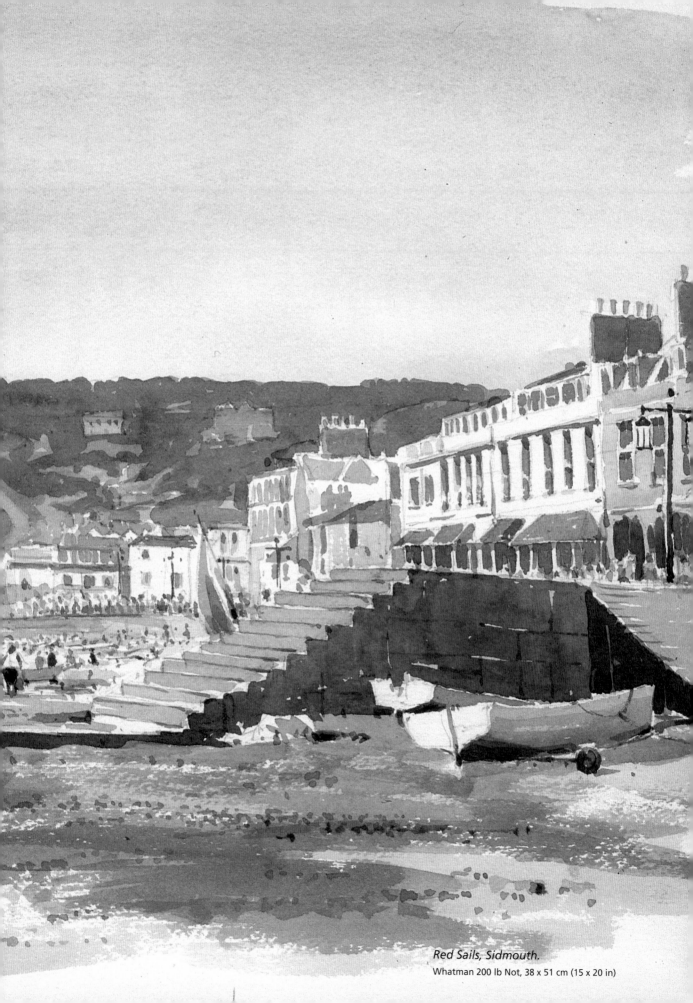

*Red Sails, Sidmouth.*
Whatman 200 lb Not, 38 x 51 cm (15 x 20 in)

*March Sunshine.*
Whatman 200 lb Rough, 51 x 38 cm (20 x 15 in)

*Autumn Sunshine.*
Whatman 200 lb Rough, 51 x 38 cm (20 x 15 in)

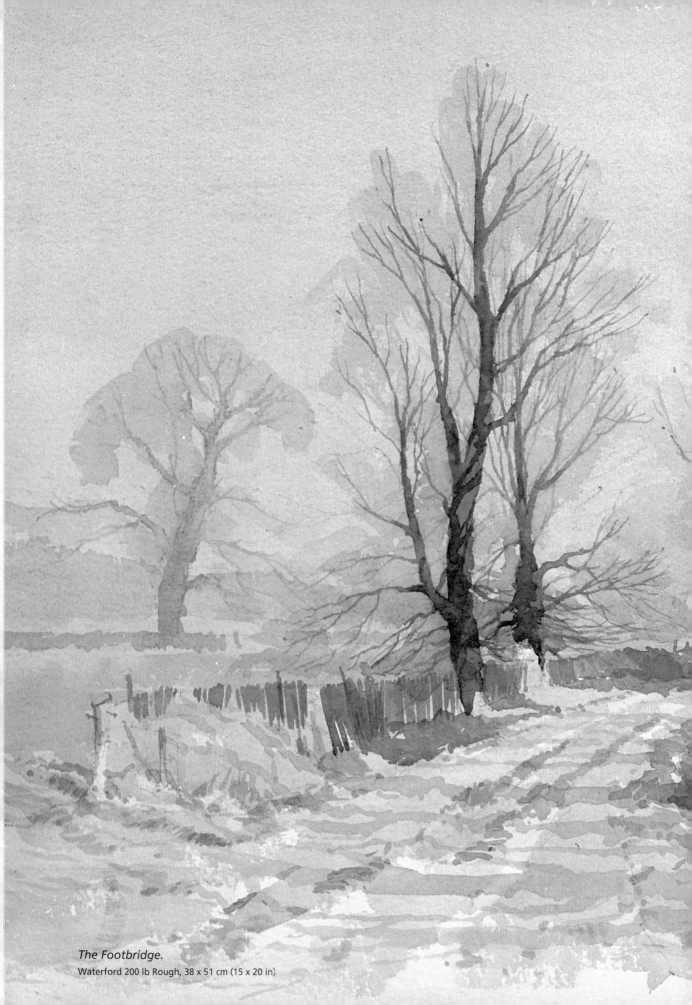

*The Footbridge.*
Waterford 200 lb Rough, 38 x 51 cm (15 x 20 in)

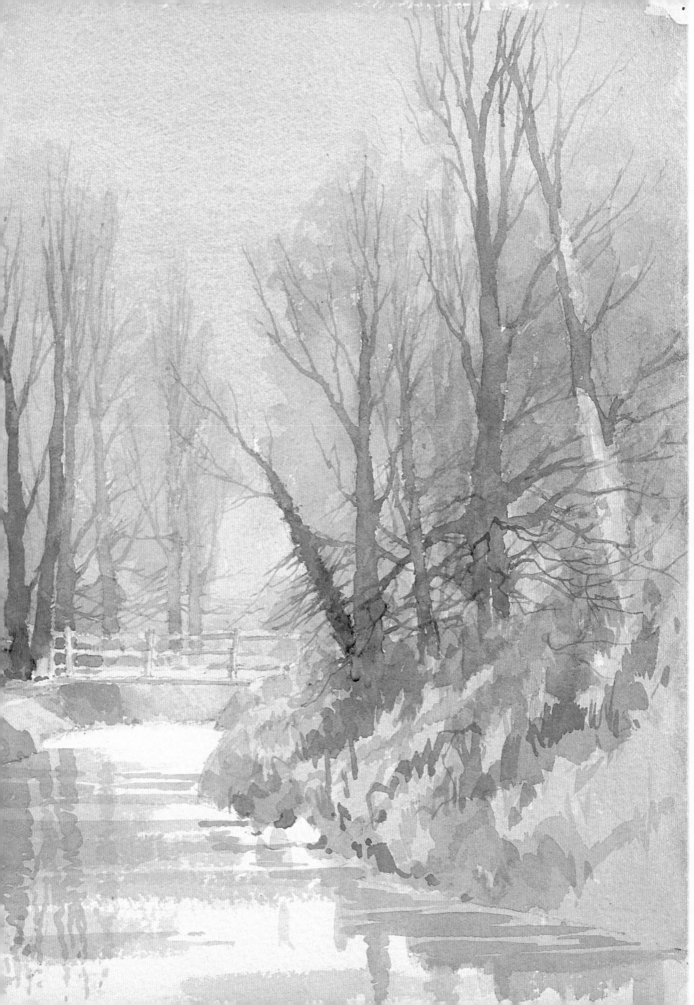

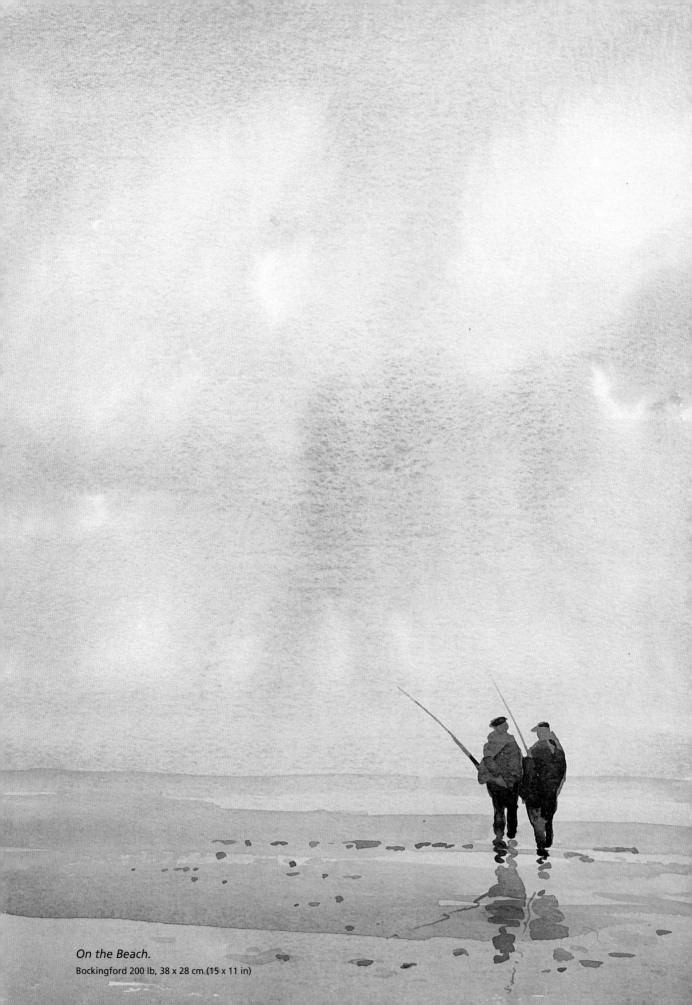

*On the Beach.*
Bockingford 200 lb, 38 x 28 cm (15 x 11 in)